Airbrush Painting
Advanced Techniques

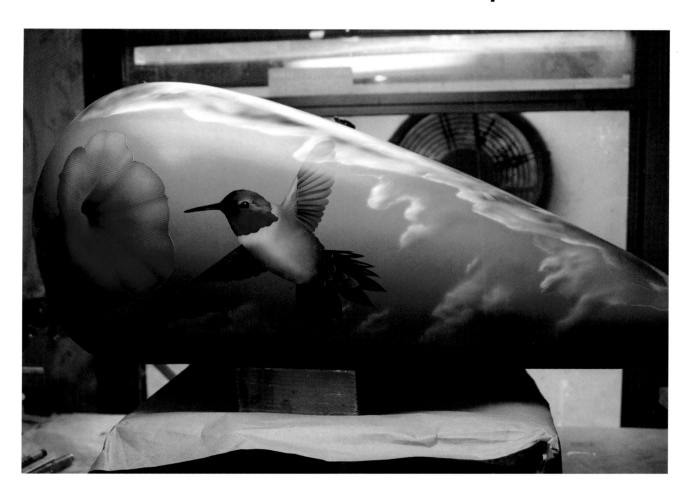

By JoAnn Bortles

motorbooks

Dedication

To David.

First published in 2009 by Motorbooks, an imprint of MBI Publishing Company, 400 First Avenue North, Suite 300, Minneapolis, MN 55401 USA

Motorbooks titles are also available at discounts in bulk quantity for industrial or sales-promotional use. For details write to Special Sales Manager at MBI Publishing Company, 400 First Avenue North, Suite 300, Minneapolis, MN 55401 USA.

To find out more about our books, join us online at www.motorbooks.com.

Library of Congress Cataloging-in-Publication Data

Bortles, JoAnn, 1960-
 Airbrush painting : advanced techniques / JoAnn Bortles.
 p. cm.
 Includes index.
 ISBN 978-0-7603-3503-1 (sb : alk. paper)
 1. Motor vehicles--Decoration. 2. Airbrush art--Technique. 3. Decoration and ornament. I. Title.
 TL255.2.B683 2009
 629.2'62--dc22
 2009016380

ISBN-13: 978-0-7603-3503-1

Publisher: Zack Miller
Editor: Peter Schletty
Creative Director: Michele Lanci-Altomare
Senior Design Manager: Brad Springer
Designer: Linnea Fitzpatrick

Printed in China

About the author

JoAnn Bortles is a nationally recognized and award-winning custom painter. Her work has been featured in dozens of magazines, and she has written five books on custom painting techniques for Motorbooks, including the bestselling *How to Master Airbrush Painting Techniques*. She lives and works in Waxhaw, North Carolina, running her own custom painting shop, Crazy Horse Painting.

Contents

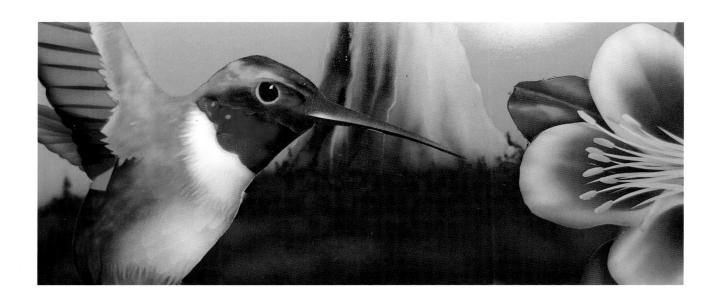

Acknowledgments

Many thanks to the staff of Dan-Am SATA USA. Their spray equipment makes my life easier, and they are wonderful people.

Thanks also to:

Bent and Knud Jorgenson

Tony Larimer

Scott Barlow of BelAire Compressors

Gary Glass and Iwata Medea

Artool Shields

Ken Schlotfeldt of Badger Airbrush Company

Keith Ball

Peter Schletty

Darwin Holmstrom

Jon Kosmoski, John Hall, and Nick Dahl of House of Kolor

Margorie Kleiman

Chris Callen of *Cycle Source*

Lindsey Beattie

Sheri Tashjian Vega

Jennifer Marquart, for making me look good

MaryAnn Surrete

Introduction

This is the sixth book I have written about custom painting and airbrushing. I wanted this book to be different than the others, so I have designed it to work with my fourth book, *How to Master Airbrush Painting Techniques.* That one has very comprehensive chapters on tools, materials, and steps on how to handle an airbrush. This book picks up where that book left off. There are no chapters on airbrushes or tools or paints. Instead, it is all technique and theory. Do you ever ask yourself how particular artists got their style or how they came up with those ideas? Those ideas are what this book is all about. It deals with real-world situations and solutions.

An airbrush artist has to learn how to think, how to plan the process of each mural, what to work on first, what to do when the mural does not go as planned, how to keep from getting discouraged when your artwork goes from bad to worse, and how to turn it around before you completely give up.

The artist must also learn how to think of ideas, how to take ideas and play with them (for example, trying unusual colors for backgrounds), and how to take a bad idea and make it a good one. Like my other books, this book deals with problems and how to solve them, how to think your way through a problem, and how to recognize your strengths as an artist and make them work for you. Being a successful painter means knowing your weaknesses and how to best deal with them.

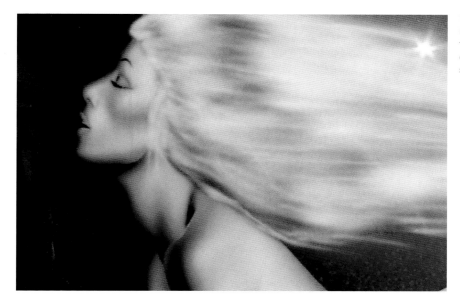

Look at this woman's face. It is less than an inch wide, but note how clear her expression is. What airbrush techniques were used to create it? Why is this face so effective? Why does it look so good? For the answer, see Chapter 11.

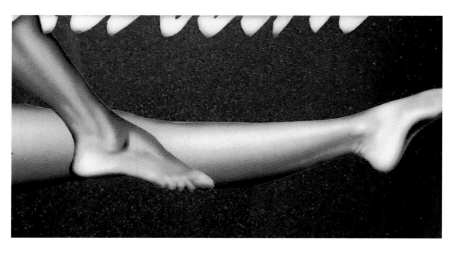

What makes a good airbrushed pinup? Attention to detail, that's what. I cannot show this mural in its entirety, but one thing that makes it so effective is the way I airbrushed details like the ankles and feet. I spent over an hour on them.

What makes a good airbrush artist? It is very easy to get discouraged in the art of airbrushing. I like to say custom painting is a combination of common sense, discipline, technique, and artistic talent, with common sense being the most important factor. There are two kinds of artists: those who get so completely lost in their art that they do not want to deal with the outside world and the business end, and those who understand business and work it to their advantage.

Scott Jacobs, one of the best known artists in the world, started out as a businessman and then got into his art. He made his art work for him, which is not as easy as it sounds. Another airbrush artist, one I consider the best, doesn't like to answer his phone and is not at all easy to find. Needless to say, he has not made a fortune from his art, and his name is known mostly by other airbrush artists who marvel at his incredible artwork.

For me, an ideal day is working in my studio, with no phone ringing and no disruptions. For self-employed artists, however, who have no one to answer their phones or run their businesses, this method doesn't always pay the rent.

So good artists must learn to balance work time with business time. Use common sense and discipline to make the most of your artistic talent.

I love painting stormy scenes. It is one of my strengths as an airbrush artist, so I paint them as often as possible. If I loved painting dragons, then I would paint more dragons. Know your strengths and make them work for you.

Whenever you look at a photo, whether it is a picture of a mural or just a photo of real life, don't just look at it—examine it. Go over every detail: how the light hits the various subjects, how the structure of the object goes together. These are things that will help you become a better artist. For example, look at this picture. How did I create this mural? What techniques and processes did I use? By the time you finish this book, you should be able to easily reproduce this airbrushed mural.

Chapter 1
Designing a
Mural Background

Any airbrushed mural can be manipulated by the design of the scene. Items or elements can be added or taken away, or their sizes can be changed. The direction of light and how light or dark the mural is can completely change its appearance. In this chapter I will be showing some examples of mural design and how a mural is envisioned, designed, and put together. I will also be airbrushing a mural that shows a daytime scene. Chapter 2 will feature a sunset or low light scene, while Chapters 3 and 4 will show the airbrushing of the foreground area of the mural.

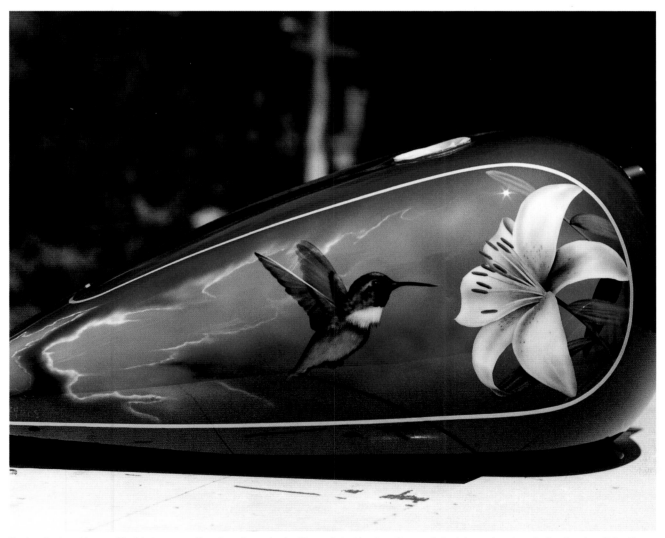

Here's a simple and fun mural I painted years ago. Sometimes the most enjoyable murals to airbrush are the ones that only have a few elements. Here is a sky with two items in the foreground, a hummingbird and a flower, yet in no way does the mural look "simple."

DESIGNING A MURAL

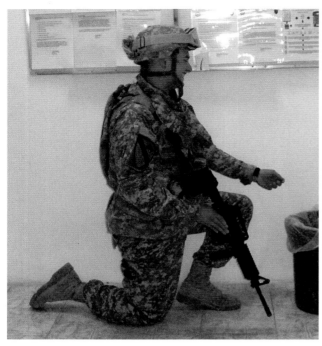

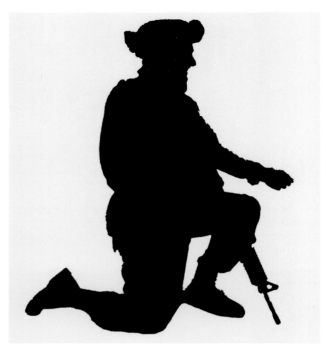

Keith Coleman, the owner of this bike, is a career soldier and wanted murals that showcased his feeling about war. For one mural, he wanted a soldier helping a small child. In the background of the mural, he wanted it to feature soldiers through history. Here, Keith has a photo he took of a soldier kneeling down as if to reach out to a child.

Using Photoshop, the soldier is drawn in silhouette, since the foreground characters will be sharp black silhouettes.

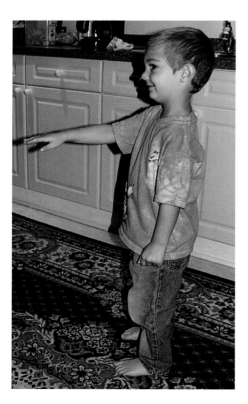

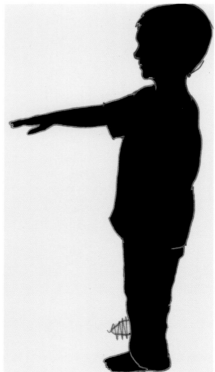

For the child I had my godson, Chase, pose as if he were reaching out to someone. Then I drew that in black silhouette.

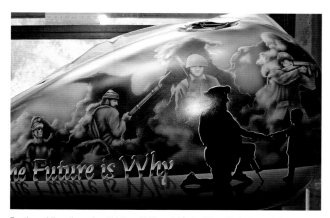

PLOTTER-CUT STENCILS

This lettering was done using a plotter-cut stencil. Most airbrush artists use them to create sharp-edged lettering. This book does not feature a chapter on this technique, but it can be found in *How to Master Airbrush Painting Techniques*. Can lettering be airbrushed freehand? Yes it can, but most of the airbrushed lettering you see was done with stencils.

For the soldiers throughout history, Keith and I looked for old photos and drawings online and in books. These images gave me an idea of how to dress and pose the characters. I could have airbrushed the foreground characters to look like their photos, but then it would have given them a confined identity. By drawing them in black silhouette, they could be any race, any nationality. It also gives balance to the mural, since the background is rather detailed and complex. To have a great deal of detailed artwork in the foreground as well might take away from the mural. The simpler mural makes a bolder statement by focusing on the background and the message of the lettering.

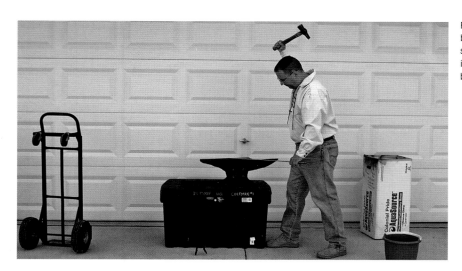

For the other side of the tank, Keith wanted a blacksmith forging a sword. He poses as a blacksmith, showing me exactly how he sees the scene, putting items in position. The blue bucket is where the quench barrel will be. The white box is where the forge will be.

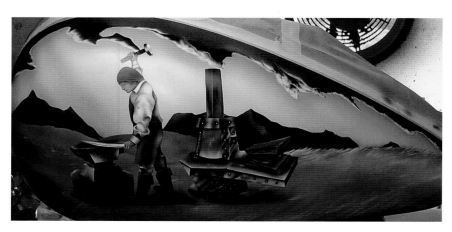

Here is the mural. Note how the background is in sharp focus. Compare it to the mural in the following section. In that mural, I play with the background and foreground focus. It makes a big difference. Plus, note how there is no direction of light. I did not want a light source or direction of light in this mural. The result is a dreamy, mystic, yet not realistic, effect.

DESIGNING AND AIRBRUSHING A BACKGROUND

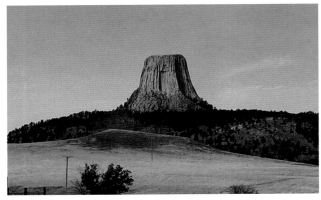

The owner of this bike is from Wyoming and likes hummingbirds. She wanted her bike to feature these themes. So first, before I designed a paint job that would use both, I needed to do some research. I found photos of hummingbirds, flowers, and scenes of famous Wyoming landmarks. Devil's Tower is one the most identifiable landmarks from Wyoming, and I have photographed it several times. For this mural, I'll airbrush Devil's Tower with a field below it and, in the foreground, a flower with a hummingbird, both of which will be in very sharp focus, while the background will be slightly out of focus. This will give the mural a more realistic look than the previous mural.

Here is the blank canvas with which I have to work. I'll need the purple color to come through as much as possible. If I cover large portions of the purple, I'll have to work purple into the foreground elements, like the bird and the flower.

First, I mix up a batch of light blue and start spraying the sky. A torn piece of cardboard makes a great tool for masking off the areas I don't want to be blue. Because I want the blue to cover the area evenly, I crank the pressure up so the paint disperses in a fine pattern and is not splotchy.

PERSPECTIVE

This photo shows a mural I painted many years ago. Do you see a problem with it? Perspective plays a major part of designing any mural, since it refers to how close or far away an object appears to be. Perspective in an airbrushed mural is mainly manipulated with the focus of its components. For example, for the background to appear farther away than objects in the foreground, the background should be out of focus. Objects in the foreground should be in sharper focus.

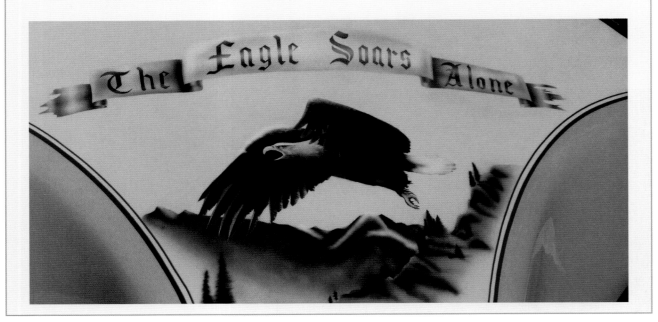

DIRECTION OF LIGHT

Can the direction of light make a big difference? Yes it can. Compare the photo on the left to the one on the right. A flash was used to take the left-side photo, so there isn't one specific direction of light, whereas the direction of light in the photo on the right can clearly be seen. The shadow that is created gives the object shape, dimension, depth, and form. It has less of a two-dimensional feel. Take photos of your subject showing various degrees and directions of shadow.

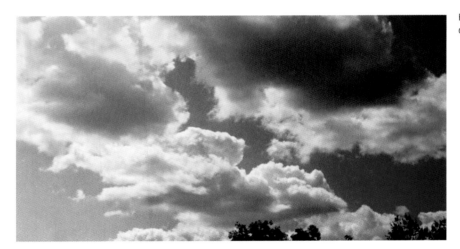

Here is a good example of cloud structure, the way the cloud forms and "billows" out.

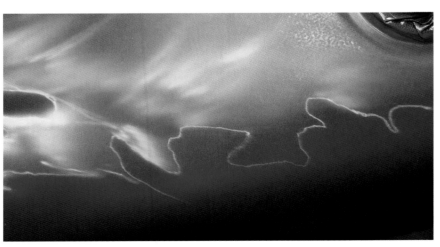

For the clouds, I airbrush a fine line along the edge of the clouds. Then, little by little, using low air pressure and thinned-down light blue paint, I start to build up the surface of the clouds, using my reference photo to show how the darks and lights land on the cloud surface. These depend on the angle from which the light is coming.

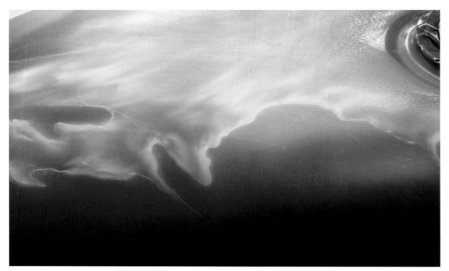

I use little circular movements with the airbrush, choosing the angle from which the light will hit the cloud surface, and then softly build up the light areas of the cloud. Compare this picture to the previous one. Note how I changed the border of the cloud, moving it back in the middle area.

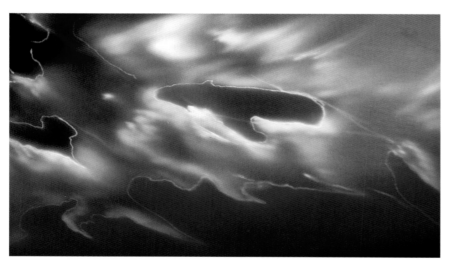

I add openings, and again, it's all a matter of building up the surface using lights and darks. For the darks, I let the base color show through, then softly airbrush very thinned-down purple and blue. These colors are nearly transparent tints that are reduced down.

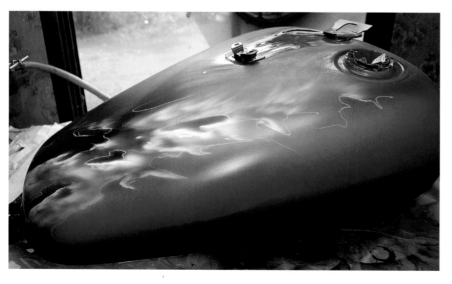

I want as much of the base color to show through as possible, even though the surface is nearly covered with artwork. Here is the completed sky.

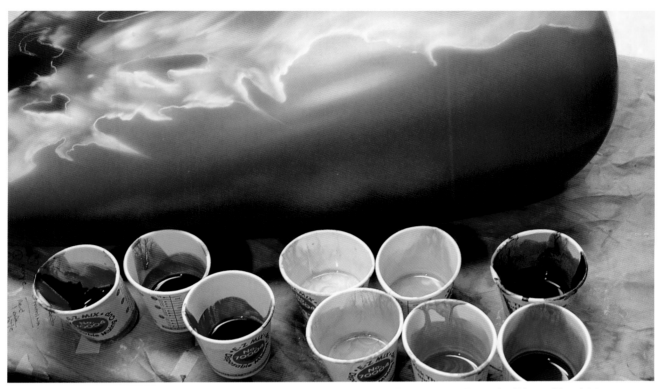

Don't be afraid to mix up colors. I ended up with six different colors of blue and three purples. The only difference in the purples was the thickness of the paint; two were very thin. I will add white or black or colored tints. This happens with nearly every mural element I paint.

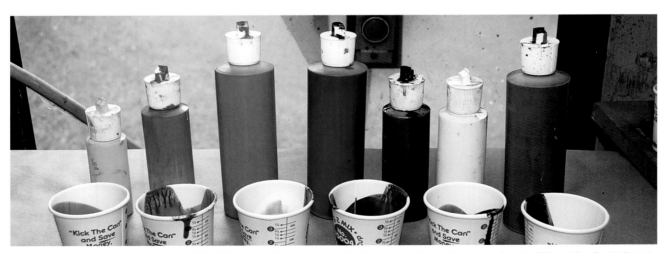

Here, I'm getting ready to airbrush the scenery and Devil's Tower. Note the colors in the bottles. Those are what I am using to mix up the colors I'll be painting. I'm starting out with six color mixes. I'll easily double that by the time I am done, varying each color slightly as I go through the mural.

AIR PRESSURES

One often-asked question is about air pressure. Air pressure depends on a number of things, such as the kind of airbrush used, the air source, and the thickness of the paint. A general rule of thumb, though, is the finer the detail, the less pressure that should be used. This is because the paint for fine detail is thinner and doesn't require a great deal of air. But what if you need to cover a large area with paint? Use a higher pressure, even if the paint is thin.

I draw a line with a white Stabilo pencil to position my horizon.

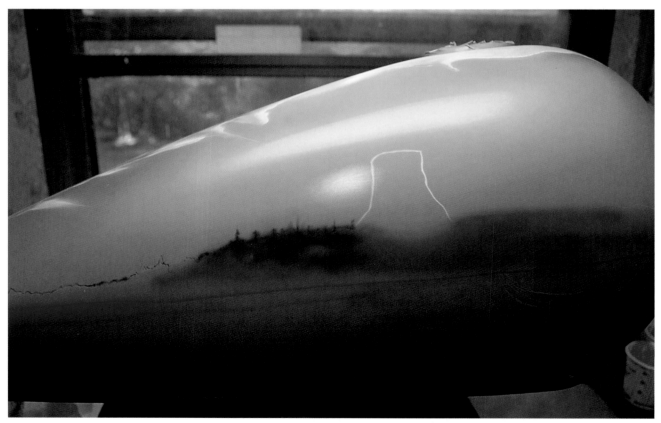

Next, I start laying down the light brown of the hillside. Then I airbrush thinned black for shadowing under the trees and the green of the trees and brush. I'm keeping the whole thing light and loose so it will appear slightly out of focus. Remember the items in the foreground will be in sharp focus.

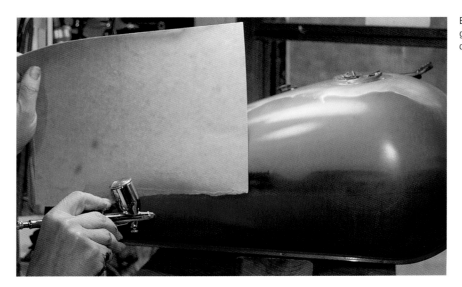

Even though I am not done with the hillside, I want to give some presence to the field below. I use the torn cardboard to lay down some light green.

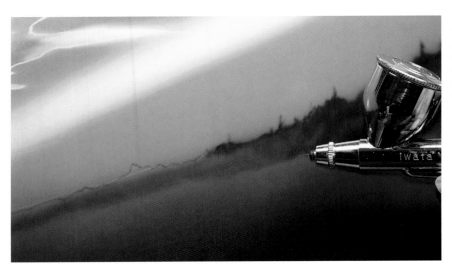

Here is a super close-up of the technique used for the horizon and the trees, a soft thin line filled with brown. How do I get that thin line? Very thinned-down paint and low pressure, maybe 20 pounds. Plus, I am using a very fine airbrush, an Iwata Eclipse HP-CS with the crown cap removed. By removing the crown cap or spray regulator, I can get very close up to the surface.

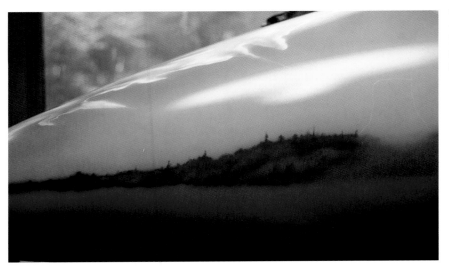

Wow, it's starting to look like something! Little by little, the design is coming together. Don't get discouraged if you don't see what you are after right away. Sometimes you need more than one mural element to see good results.

COMPARE, AND THEN COMPARE AGAIN

Most printers have a copier function. Use it. I must make at least three to six different sizes of every item in a mural, and sometimes I make more. I compare them until I find the right size for that item. Don't restrict yourself to the size you think you need. Give yourself a choice. It is a horrible feeling to reach the end of a finished mural and see one little thing that makes you think, "If only that was a little bigger." Work that out with each element as you go through the mural, even if you have already done a drawing. Everything tends to change once you get on the surface of the mural. Don't rush through the mural and make simple mistakes. Take your time.

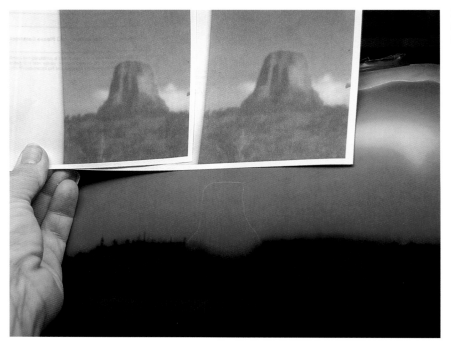

Now for Devil's Tower: I make copies of it in various sizes, and then compare them on the mural to see which size will work best.

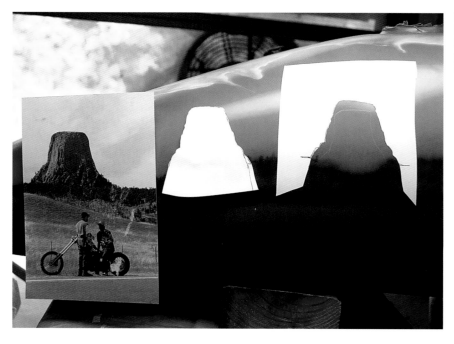

Note how I end up with a larger Devil's Tower than I had planned. I cut the landmark out of Gerber Spray Mask. Gerber Spray Mask is designed for use in plotters, but I also use it for hand-cut stencils. I use a No. 11 X-Acto knife to cut the figure out.

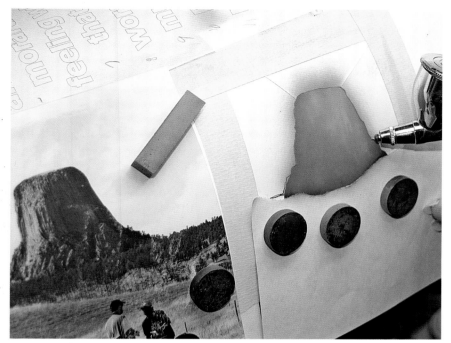

Now I have to make the light hit the Devil's Tower in my mural from a different direction than in the photo. Why? I want the light source to come from the front of the tank. I need it to light up the front of the hummingbird, which will be in the foreground. If I use the light as it is in the photo, the bird will be mostly in shadow. So I have to change sides of Devil's Tower to make it as it is viewed from the western side, even though my photo shows the east side. I've laid down some light brown and am airbrushing on light brown that has more white in it. I want a fuzzy edge, so I mask off the bottom of Devil's Tower with torn paper held in place by magnets.

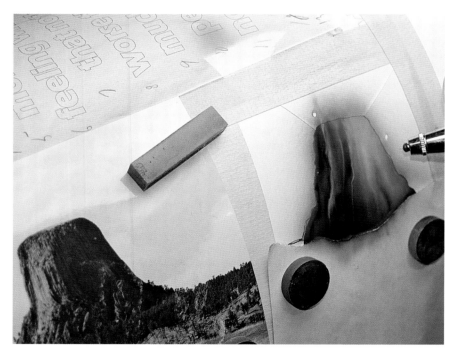

Now black is airbrushed on. I spray light, then dark, and then light again, building up the surface of the landmark. One problem I am seeing is that the detail is too fine. I have to "fuzzy it up" a little. The entire background needs to be slightly out of focus.

DEALING WITH POOR RESULTS

What if you don't like the mural item you just finished painting? Simply re-spray it. In the case of this mural, since the colors are solid and easy to cover, if I wasn't happy with the Devil's Tower, I could just re-spray it brown and start over. If the mural was done in transparent colors, it would be more difficult to start over. In that case, I would have to lay down a new base to cover what I had done. The point here is, don't panic or get nervous if the mural is not going in the direction you want. Just step back and take some time away. Then return to the mural and think about the best way to proceed.

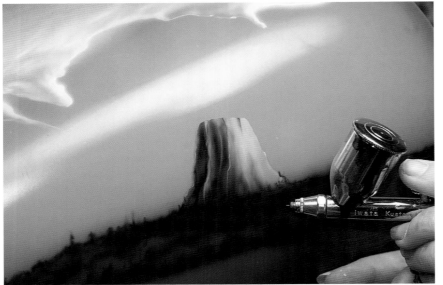

The mask is removed from Devil's Tower. Then little trees are airbrushed around the base. I spray some black and then some green, using small movements with the airbrush. I have to keep in mind the size of Devil's Tower. I have seen it in real life, and it is huge, much larger than the trees. So to keep it in perspective, the trees will have to be very small. This will make the landmark look the right size. If the trees are too large, then it will not look as big. This is something to remember as you airbrush your way through a mural. An item can be made to appear larger or smaller, depending on the size of the items around it.

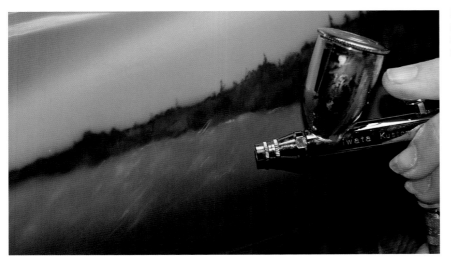

Now for the field: I mix some yellow into the same green I airbrushed for the field. I airbrush slight strokes of this color randomly across the field. The stroke sizes are varied, keeping it very random. No patterns.

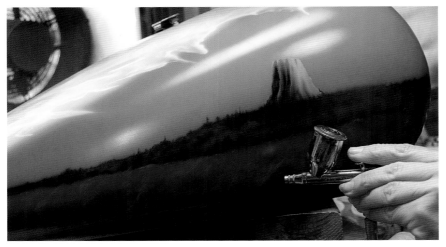

A thin wash, made up of dark green transparent tint thinned down with reducer, is lightly sprayed across the field. Then I go back and add more of those yellow strokes. This builds up the surface of the field, adding depth. The yellow I applied previously is now darker and will appear deeper in the field than the new yellow strokes. OK, the background for this mural is done. Chapters 3 and 4 will show how this mural is completed.

MORE CLOUDS

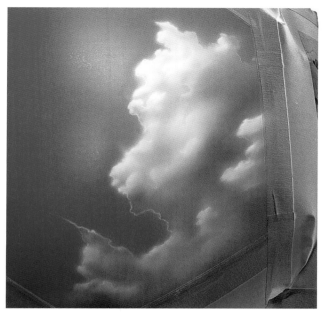

This is another cloud background. The progress of this mural is shown in Chapter 7.

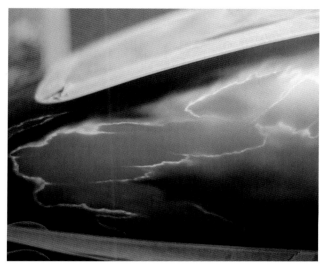

Sometimes the simplest clouds can be extremely effective, like the detail from this mural. Just the outer edges of the clouds are lit by the sun to create a timeless effect.

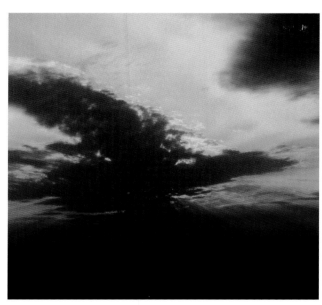

Here is a photo that was taken of a sunset back in 1987.

The photo was used as a reference for this mural painted in 1993.

WHERE DO IDEAS COME FROM?

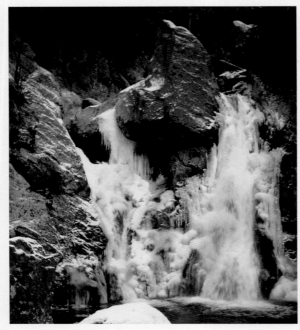

Here is a frozen waterfall.

This is the mural for which I used it, but note the changes. First off, it's not frozen. Secondly, I only used the left side of the waterfall and made the whole feature longer. Reference photos can be used for ideas, too. You don't have to paint it exactly like it is in the photo—change it, play with it.

COVERING A SURFACE WITH MURAL?

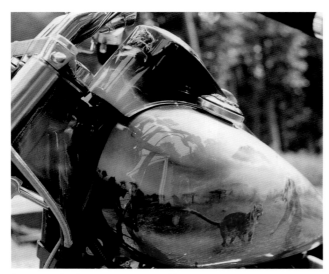

Sure why not? In fact, you can have a lot of fun with it, but try to make the side of the tank be the main part of the mural. Use the brighter colors there and keep the darker, softer colors on the edge areas of the part. There is a lot of action on the side of this tank with two lions fighting, but notice how the background starts to change and turn darker. Also look carefully where the tank meets up with the front of the dash and see how the mural continues up there. It's just clouds with a hawk, but it adds so much.

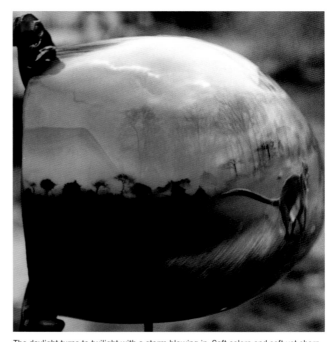

The daylight turns to twilight with a storm blowing in. Soft colors and soft yet sharp details are used to create this effect.

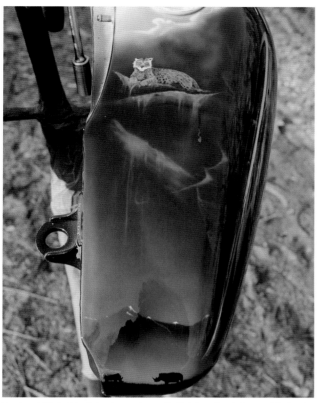

The top of this tank is dark colors and serenity. Note how the darkness of the jungle canopy at the top easily morphs into the nighttime sky with a mountain and rhinos.

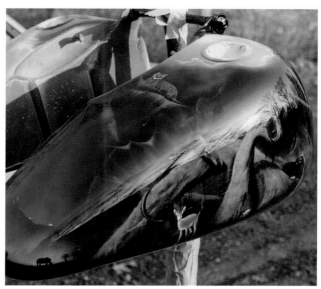

Here's the other side of the tank. Again, bright colors and lots of action are applied. Leopards are crawling, ready to attack a deer.

PUTTING IT TOGETHER

Look carefully at this fender and make note of all the things going on. There is an eagle flying up high in the sky, over a lightning storm that is over an icy mountain scene with a snow wolf sitting on a glacier. Now, there was no photo that contained these items together. They were all individual things that seemed to go together—bits and pieces from my photo reference library.

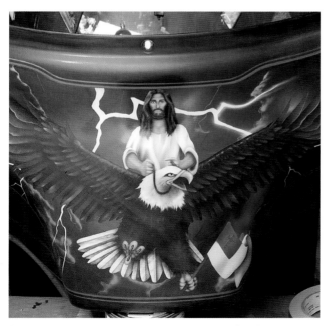

Progress on this mural can be seen throughout this book in a few of the chapters. This is the result of all the elements of an airbrushed mural working harmoniously together—using photos for references and ideas, paying attention to little details like reworking the face four times, and just about everything that is covered in this book. And yes, it is a mural of Jesus.

Chapter 2
Airbrushing a Sunset Background

Take notice of the lighting in this mural; it is the reason why this mural is so strong. Very soft yet simple colors and elements in the background frame the water buffalo featured in the foreground. The lighting on the buffalo makes the most of the creature's details. It doesn't show every specific line of the buffalo, just whatever a sunset light would illuminate. When painting low-light scenes, keep in mind the amount of light in the mural's background, and make sure the lighting on the foreground features matches it.

There are no hard, fast rules for putting together the background of a mural. The background can be pieced together using elements from various photos or sources, or the artist can take all elements from a single photo or source, or maybe the idea can come directly from the artist's imagination. No matter where the idea comes from, the background can be one of the most enjoyable parts of the mural to create. It is an area where the artist should simply relax and let creativity flow.

MATERIAL AND EQUIPMENT LIST

House of Kolor Kandy Koncentrate
Iwata Kustom CS Eclipse
Iwata Kustom CH
SATAgraph 3 airbrush
EZ Mix cups #70008
Paper
Magnets
Paint will vary depending on style of background painted

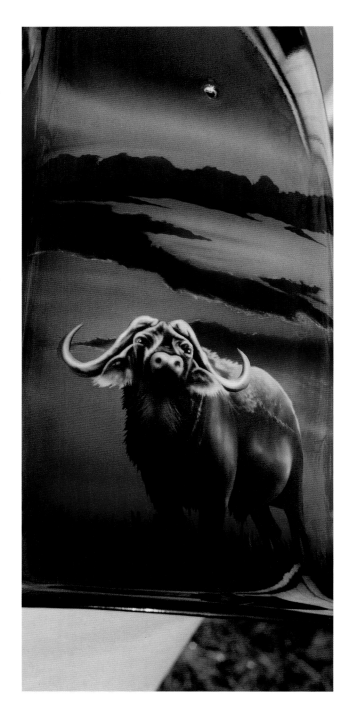

HOW THIN IS THIN PAINT?

How much to thin down paint is one of the questions I hear most often. While the answer is simple, it is not what people want to hear. There is no one answer. Each type and brand of paint is different. Each airbrush sprays differently, as does each artist. Play around and find the best paint thickness and air pressure combination for your style of airbrushing. Be patient and have fun with it.

The best answer is to experiment and to thin as you go. Also keep in mind that the thinner the paint is, the less pressure will be needed. Thicker paint requires a higher air pressure. If the paint is grainy or the airbrush "spits" the paint, then try upping the air pressure or adding a little reducer or water, if using water-based paint. Find what works for you.

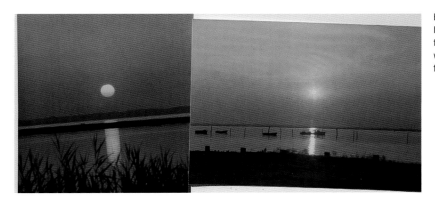

Here, I'll be using elements from several photos. I want the reflections from the water, the yellow-toned and warm colors from the sky, and the way the clouds are arranged. What I am trying for is a moody sunset over the water.

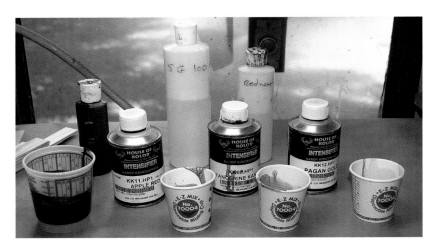

First, colors for the background will need to be mixed. Since I want soft translucent tones, I'll use transparent colors, in this case, Kandy Koncentrate colors from House of Kolor.

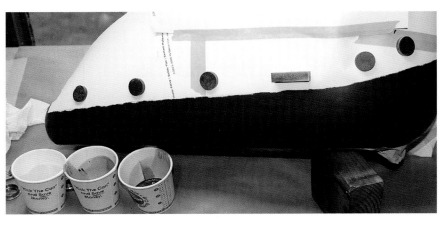

Now a few solid colors are needed to lay down the base for the background sky. I will mix up two tones of gray: a light and dark and a yellow/white mix. But why gray? Look closely at the photos. See the large amount of gray? Now look closely at the cloud edges and note the slight roughness. A torn sheet of paper will work effectively to duplicate that soft edge.

23

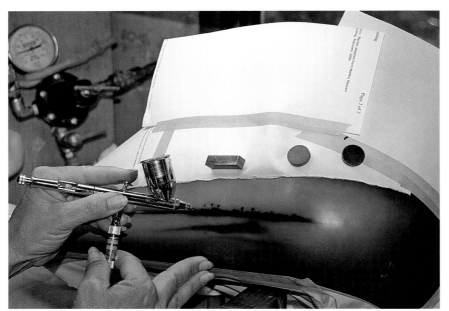

I pick a place on the gas tank to start the horizon and begin airbrushing the light gray. The paint I am using is very thin. Then, with the black, I airbrush little palm trees. I want the viewer's perspective to appear to be very distant, like high up in the sky. The area below the torn paper will be water, and the palm tree border will be marshy land in the water. This will give the impression of just how far away the background is. I keep the trees and marsh slightly out of focus. Here is where having photos comes in handy, since not everything in a photo is in the same sharp focus. Different distances have different focus amounts. Look at the photo of the sun over the water and see how the focus varies for each item in the picture.

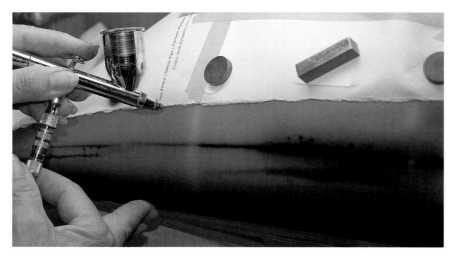

Now some yellow is lightly airbrushed on to start the sun reflection on the water. I'll be going back over this, but for now I just want to start building up the tones to get an idea of how I want to continue with this buildup.

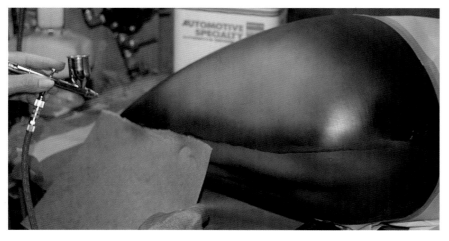

After removing the paper, I decide that the horizon is too high. I'll airbrush on some black using a torn piece of cardboard to lower the horizon, and then yellow to start toning in the sky. I'm making this up as I go along, while keeping the photos close by for reference.

FINE LINE HINT

Most double-action/internal mix airbrushes have a spray regulator or crown cap that can be removed. This allows for closer work and finer detail. But take care because this exposes the tip of the needle, which can very easily be damaged.

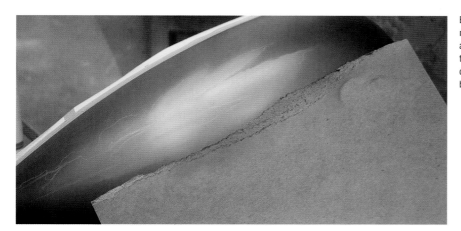

Building up the layers of clouds is not as hard as it may seem. The outline of the cloud edges is softly airbrushed on using a fine line. I get the line fine by thinning down the paint and using low pressure. Torn cardboard is used to create a soft "hard" edge. Little by little, I play around and fill in the clouds.

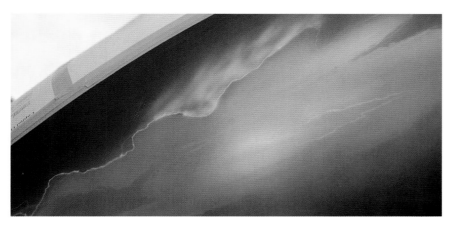

Next, I'll go over the edges of the clouds with an even finer, yet more defined, line and then softly start filling in the clouds. How do you airbrush the filler? Look closely at photos of clouds and note the way the light plays off the cloud surface. Also in this close-up, you can better see the airbrushing done in previous photos. What about all those fogged-over edges of the other clouds in the mural? Yes, they will be gone over using the same method as the edge you see here. The key is to start out soft and light, then progressively go over the edges and fill. Build up the layers.

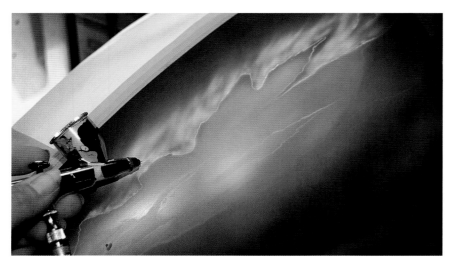

Here is the same area further along, with the cloud surfaces having been filled in. Note how light I'm working. Since I want a smooth transition where the mural fades into the base coat, I keep the paint application light as I work toward that edge. If the paint is sprayed too heavily, overspray will land past the area where I want the face to be.

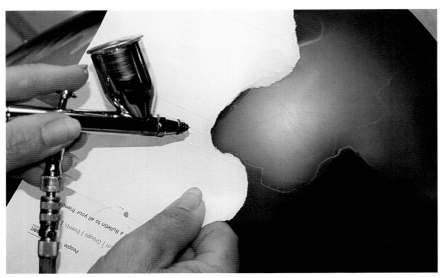

I decide to build up more cloud layers, and with the airbrush I draw out another area of foreground. Next, I tear up paper to make shapes that are roughly similar to what was drawn on the tank. Next, light gray paint is lightly sprayed. By using paper stencils, the edges stay soft but very defined.

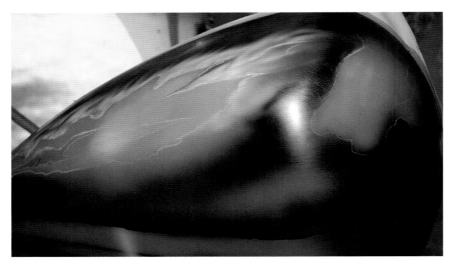

The only things I want in sharp focus are the clouds around the sun. It gives the mural an accurate feel of a distant, skyward perspective. Note how the new area of cloud gives the tank a more balanced look.

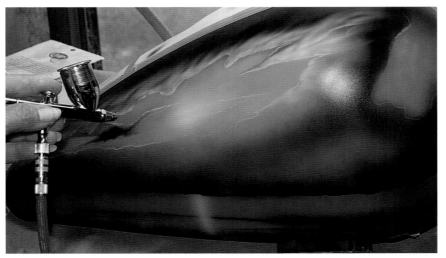

Here, I am applying the transparent colors, which are House of Kolor Pagan Gold and Tangerine. Plus, I'm still going over the mural here and there, fine-tuning the cloud detail.

EXPERIMENT!

Don't be afraid to experiment with colors or ideas for foreground items. Take a sunset sky from over a swamp, but leave out the swamp and put a city against it instead. Use your imagination to create. I highly recommend the incredible art of Frank Frazetta. Take a close look at the backgrounds of his paintings, as well as the colors and the subject matter. He paints his own world and makes it look real in an unrealistic way. Create your own world with your airbrush.

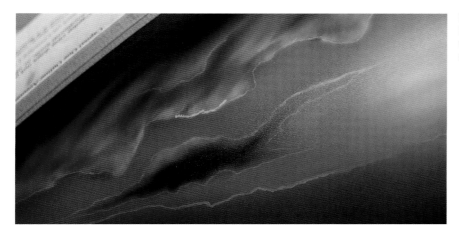

Now I add some more depth. The edges of the clouds in the foreground will be sharpened up a little more, which will make the fuzzier clouds in the background drop back even farther.

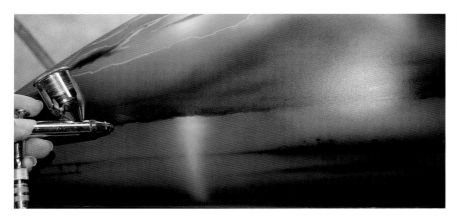

Next, I work through the mural adding detail work, like sharpening up the little trees and adding more reflections on the water.

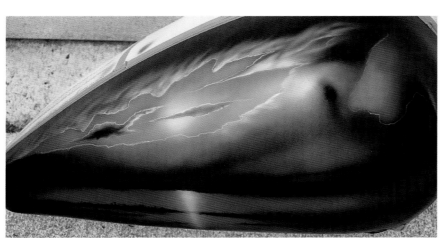

Here's the finished background. All it needs is some clear coat to protect it, and it will be all ready to work over. Anything can be placed on it: airplanes, an eagle, or whatever the artist wants.

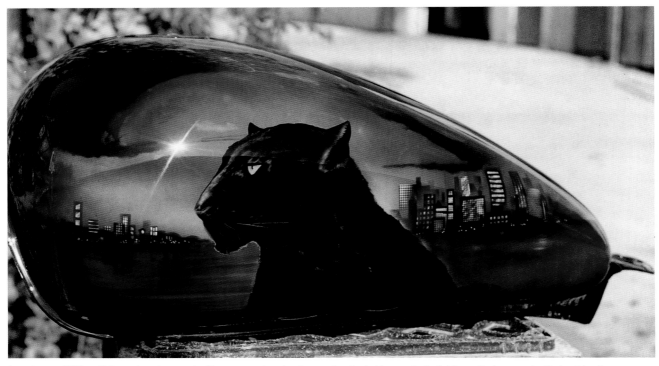

A purple sunset? Why not? A sunset can be any color. There are no rules when it comes to color. And here again, the lighting on the foreground subject matches the background lighting.

PHOTO REFERENCES

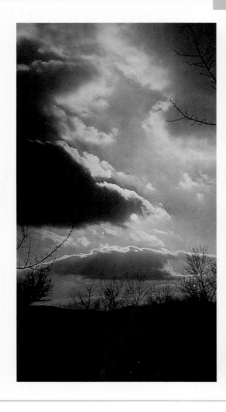

There is no way I could paint my sunset scenes without referencing the sunset photos I have taken over the years. I must have over 100 of them. I keep a camera in my car, and if I see a great sunset, I'll stop and take a few pictures. Sunsets change very quickly, so don't wait to take your photo. If you do, chances are the colors will have changed from the ones you wanted to capture.

Chapter 3
Creating a Soft Surface and Working with Stencils

Soft textures are some of the most natural things to paint with an airbrush. An airbrush is the most effective tool for manipulating the light and dark variations that define the surface of flowing cloth or flower petals or anything that does not have a visible texture. In this chapter, we'll use hand-cut stencils to airbrush the petals of a flower and the flowing cloth of a skirt. This technique can be used with anything, not just flowers or fabrics. What we'll be doing is creating highs and lows that define that surface. While this is true of most airbrushing, when creating soft surfaces the transition between the darks and lights has to be very smooth and seamless.

This chapter also continues the lesson from Chapter 1, since the project featured there is used here. This chapter helps to illustrate how mural design develops as the mural progresses through the various steps.

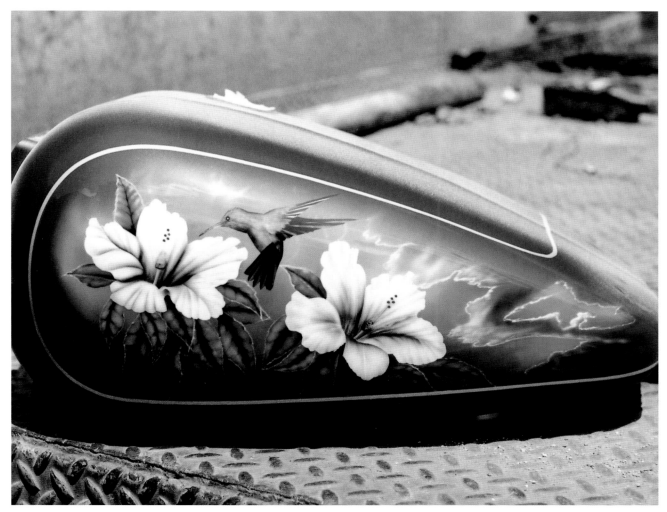

A flower petal is one of the softest surfaces there is. The airbrush is the perfect tool for creating that soft texture.

USING MULTIPLE PHOTOS FOR REFERENCE

What if you need a certain reference photo for a mural but do not have the exact picture? Combine elements from several photos. In this chapter I am airbrushing a very specific flower. My customer loves the purple or blue version of this flower, but I do not have a picture of a purple columbine with the characteristics needed for this mural. The light has to hit the flower from a certain angle, plus I need the right angle for the flower's position. I do have a photo of white columbine that is right for the mural. So I am using the white flower photo for the mural and then referencing the color characteristics from the photo of the purple flower.

This method can be used for nearly anything. Say you need a brown horse head at a right angle but don't have a photo of this. Find a photo of a brown horse and a right-angle photo of a horse's head. Use the latter photo for the angle, then simply reference the coloring from the brown horse picture.

Sometimes I'll have a number of photos mounted where I can reference them as needed as I work on a mural, even if I am not painting that exact picture. I'll also have reference material close by where I can easily see it.

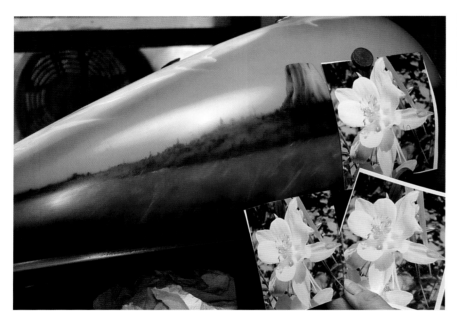

The slightly out-of-focus background featured in Chapter 1 is now complete. The flower is ready to be airbrushed in place. The flower my customer wants is a columbine, so I find a photo of a columbine and make several copies of various sizes. Then I try out each size on the mural to see which one "fits."

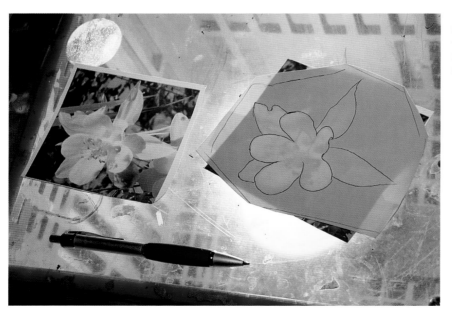

Next, using a light table, I place a piece of Gerber Spray Mask over the chosen flower photo and trace the flower. Since the mask material is solid white, I keep another photo of the flower next to it in case I need it for reference.

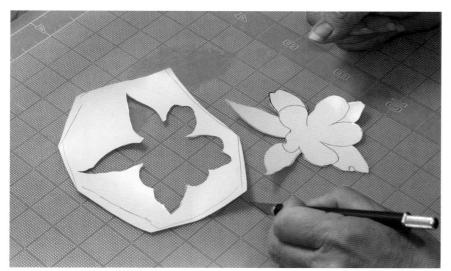

Using a No. 11 X-Acto knife, I cut out the flower on a Pacific Arc cutting mat. This mat helps me make smooth, free-forming cuts in any material because the mat has a surface on which the knife can easily slide. When the cutting surface is smooth and unrestricting, the knife can slice very freely through the material. This works much better than a wooden cutting board, which I used to use. When cutting into the wood, which is harder, the cuts might have jerky movements. I wish I had been using a mat like this years ago.

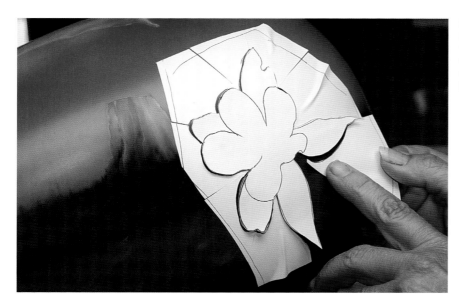

I put the cut-out section of the flower in place on the mural. Since the surface is round and the stencil is flat, I cut the stencil apart and then place it around the cutout. The gaps left in the outer stencil are taped off with 1/8-inch masking tape, and then the flower area is papered off to protect the mural from overspray.

KEEP AN OPEN MIND FOR NEW TOOLS

Just because you've been doing something the same way for years, with the same tools and it has worked for you, that doesn't mean your method and tools can't be improved. This cutting mat has made it much easier for me to create smooth cuts in my stencils. I did not see this in a book or hear about it from a friend; I was simply looking in an online art store and saw it. Now it is one of my favorite tools. While not every new tool will be a success, it is worth experimenting to find the tools that can prove to be indispensable.

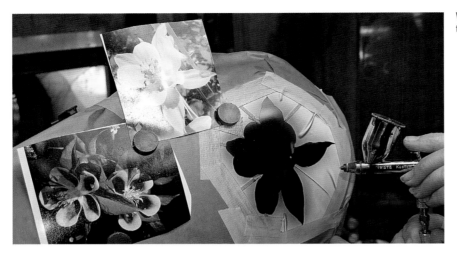

With both flower photos close by for reference, I spray the flower with a light coat of black.

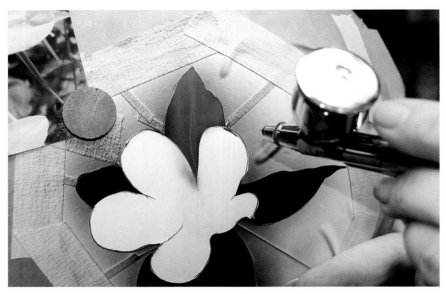

Using the cutout from the stencil, I cut out the inner area of the flower and put it in place on the mural. This will mask off the flower petals I am not working on at the moment and create clean edges for the petals. Now, using a light purple mixture in the airbrush, I pick out the light areas of the flower petal and try to duplicate them with the airbrush. Note that the crown cap is removed from the airbrush. I am also using a very thin mix of paint and a low air pressure, but not so low as to make the paint spit out of the airbrush.

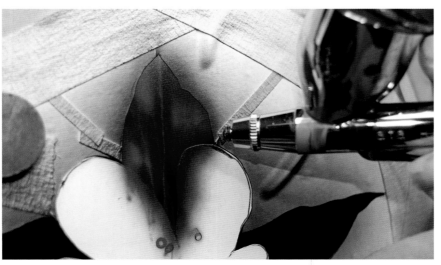

I pick out the dark areas and softly airbrush a very thinned-down black mix. The black should not appear completely black but rather should shade the darker areas. So it needs to be sprayed very lightly, not heavy handedly, or the flower will have black areas. Next, I very lightly spray a thin mixture of transparent purple over the whole petal and concentrate in the darker areas. This procedure is repeated with each petal.

WHY AM I USING THIS?

Why am I using a material for a freehand-cut stencil that is designed for a plotter-cut stencil? I could have used an airbrush mask material that is specifically designed for airbrushing and almost completely transparent and very easy to cut. But I find that when using this kind of product directly on top of freshly sprayed solvent-based paint, the adhesive can remain on the surface after the film is removed. The stencil material designed for plotters tends not to leave any adhesive residue behind. Keep in mind that I do use the traditional airbrush frisket film wherever I can, but when working over uncleared solvent base coat, I prefer the plotter stencil material.

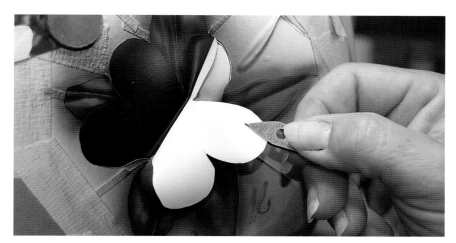

Using my Uncle Bill's Sliver Grippers, I peel away the inner cutout. Don't throw away any pieces of a stencil until the mural is completely finished. I am just going to stick this on my light table or drawing board. Sometimes I'll have tiny stencil pieces stuck everywhere. When you need a little stencil piece to make an adjustment on a mural, it is very handy and timesaving to simply reach over and grab the right piece.

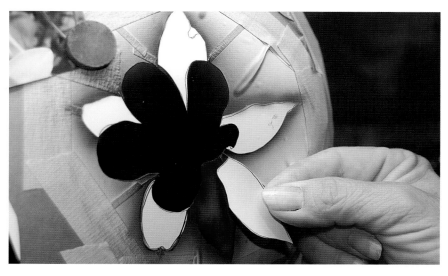

Now I take all those little stencil pieces from the outer petals and place them around the flower, stenciling or masking them off and creating a sharp edge for the inner petals I am about to spray.

UNCLE BILL'S SLIVER GRIPPERS

Uncle Bill's Sliver Grippers is one of my favorite tools. I use it to hold onto tiny stencil pieces or tape ends. Instead of using my fingernails to lift a piece of stencil, I can quickly and cleanly grab the very edge of the stencil. Or, as seen here, I can use the tweezers to hold a piece of stencil while I airbrush along the edge of it.

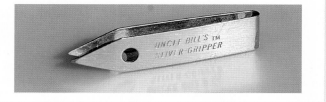

STENCILS AREN'T PERFECT

Keep in mind, stencils are not perfect. They don't always line up as expected, and sometimes they start to lift up for no reason. Be prepared to work with your stencils and refine them as needed.

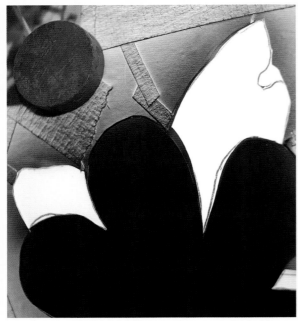

Look closely at this photo. Note how the left side of the white stencil of the topmost outer petal does not line up with the edge of the overall flower stencil. On the right side it lines up perfectly.

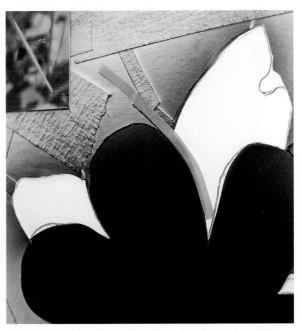

A piece of 1/8-inch fine line tape is used to lay down a new edge and fill in the gap.

Oops, the ends of the overall stencil are peeling back from the mural surface.

But a piece of fine line tape that is trimmed to fit fixes that little problem.

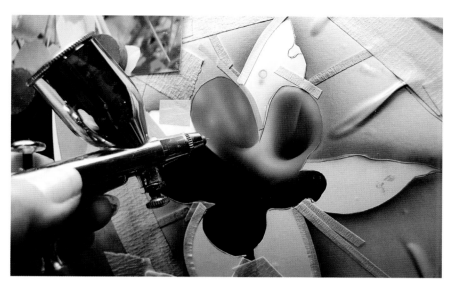

Here, I've sprayed one petal and am starting to work on another one. First, I freehand airbrush a light, thin coat of a white/purple mix in the lighter areas of the petal.

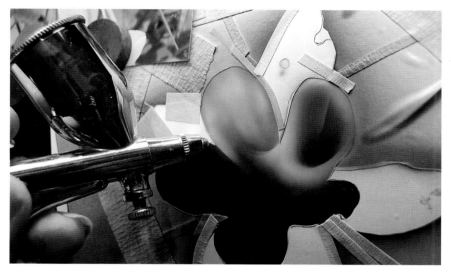

Closely looking at the photo references, more light white/purple is airbrushed on the petal. I note where the light catches the surface of the petal. This creates highs and lows; the high points are where the lighter color appears, while the lower points are in shadow.

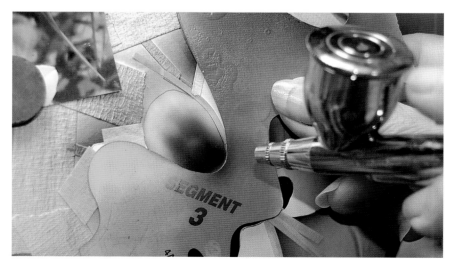

The purple version of the columbine has deep purple circular areas in the bottom center of each inner petal. To airbrush these areas and capture the way the petal forms out from the center of the flower, I'll use an Artool Match Maker stencil. These stencils come in handy for masking off areas of the flower and creating high and low points that give the flower dimension and form. Here I create the "hollow" area of the flower, where the surface of the petal drops back.

AN ESSENTIAL TOOL

The Match Maker series of freehand stencils has many different round inner and outer shapes that fit nearly any type of surface. Some of the shapes are very random, and some are nearly symmetrical. I use these stencils more than I use any other freehand stencil or shield.

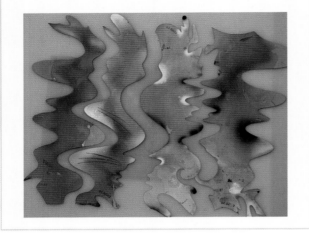

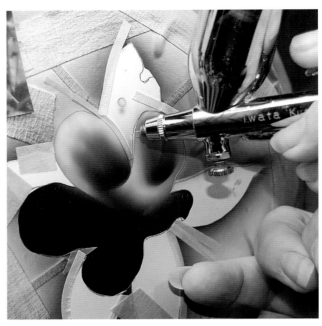

Next I look for where the light hits the surface of the petal. It lands along its outer edge, where the petal starts to curve. I softly airbrushed the light white/purple mix just inside that edge, using up and down airbrush strokes that duplicate what I see.

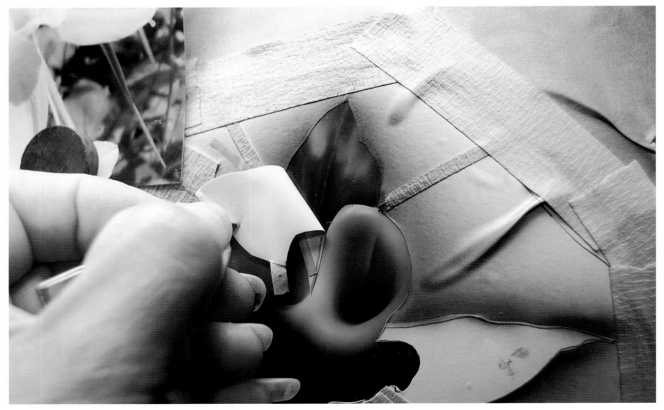

Hmm, how am I doing? Do the inner petals appear to be inside (or in front of) the outer ones? If I am not sure, I can peel back part of the outer petal stencil and check to see how it looks. It looks good. The inner petals look to be above or in front of the outer ones. Don't hesitate to peel back part of a stencil to check on something. It might save you a lot of work later on. But do it carefully so you can lay that the stencil piece down again.

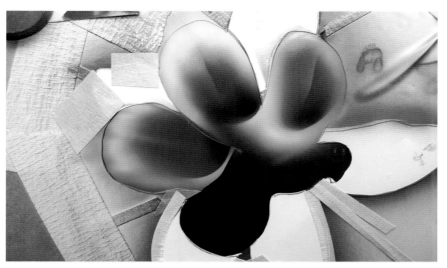

Here is my flower so far, and I see a problem. Note the straight edges on the left inner side of the flower. There must be a smooth transition from petal to petal, since all the inner petals are connected at the center of the flower. It should be more like one big petal with five lobes on it.

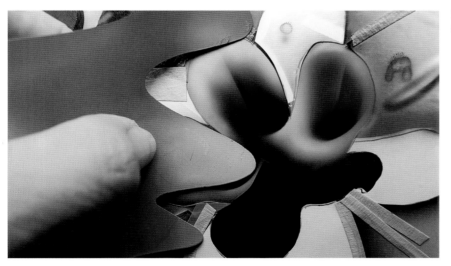

I find a shape on the Match Maker shield that fits the area I need.

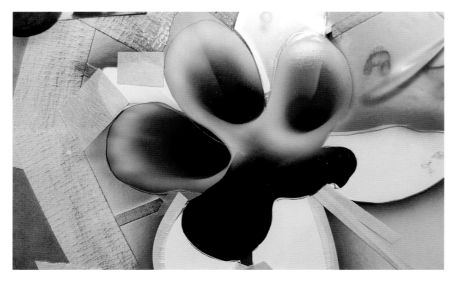

White/purple mix is very lightly airbrushed along the edge of the stencil. It doesn't cover the bottom half of the straight-edged area, but that will be remedied when I spray the next petal. Now the petal-to-petal transition is forming.

A SMALL THING

I use magnets or masking tape to hold reference photos and drawings right where I am working. That way I can see the reference photo and the area being airbrushed at the same time. But note the glare on the photo from the light.

The angle at which the picture is sitting needs to be changed so the surface doesn't catch the glare. An object, in this case a magnet, is placed against the photo, pushing it forward.

Now the photo can be seen clearly, no glare.

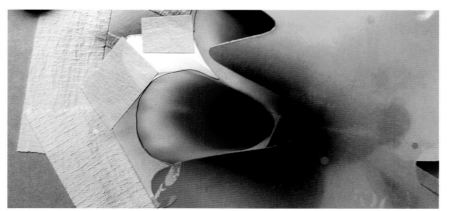

Every time I spray a light-colored mix, some overspray sneaks onto the dark areas. I fix this by using a Match Maker shield to mask off those areas and then very lightly airbrush in the transparent purple mix.

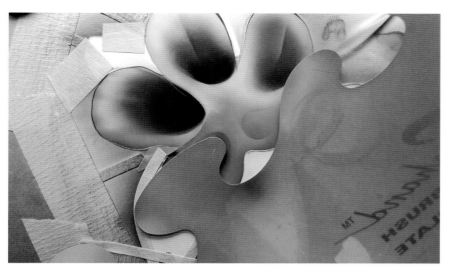

Using these freehand shields, the inner petal form is quickly taking shape. I lightly airbrush a light purple along the edge of a shape that fits the hollow in the flower petal. Here, I am using one of the Artool Essential Seven shields, the FH-6.

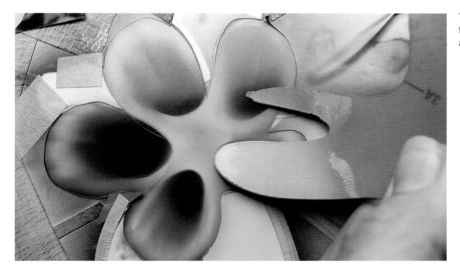

The very end of this Match Maker shield works great to mask off the raised inner area of the petal, creating a high point.

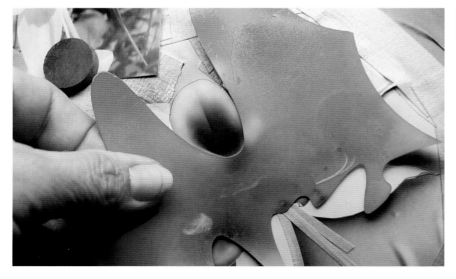

Again, I find I have to go back and re-spray the transparent purple on the darker areas—but just very, very lightly.

ANOTHER SMALL THING

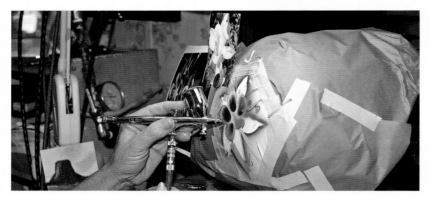

Some airbrush artists spray better with the surface of their work tilted at a certain angle. I tend to airbrush more effectively when I spray at more of a 45-degree angle. Here, I am spraying the highlights on the flower petal at a 90-degree angle. I need to change the angle of my work.

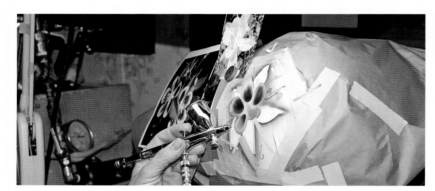

Notice the block of wood at the bottom of the tank that is holding the latter up? I simply reposition it so that it lifts the tank up higher. Now I can angle my airbrush and spray at the angle that is easiest for me; in this case, it is in the direction of the strokes I am spraying for the highlights.

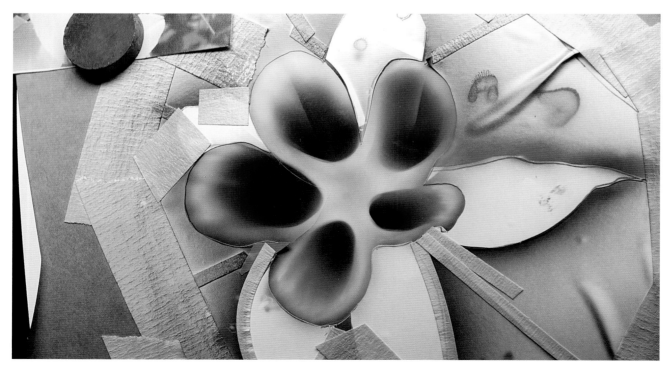

OK, the inner petal is done. I remove the stencil.

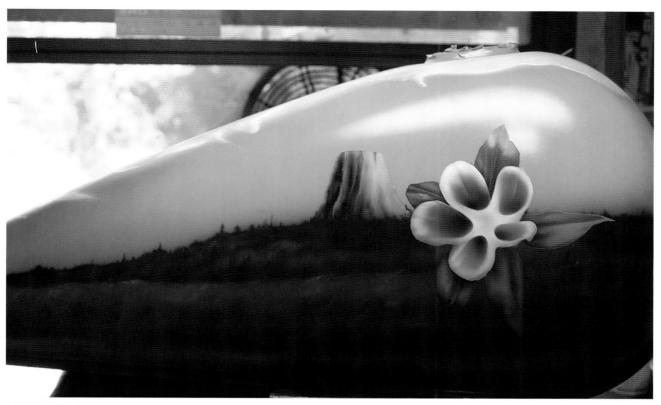

But there is still work to be done. The stamens in the middle of the flower need to be painted, plus the flower is just kind of floating around the field.

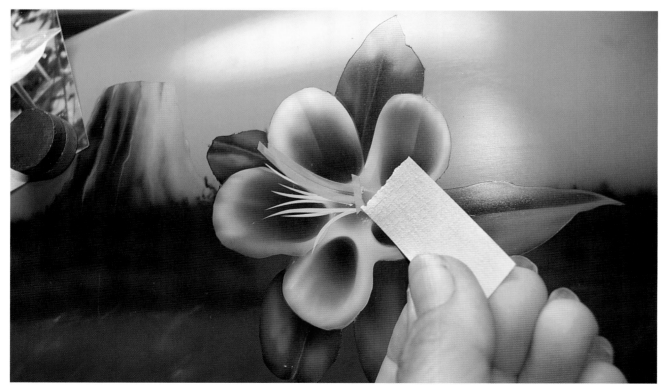

The stamens are easy enough to create. I simply use 1/8-inch fine line tape and then 3/4-inch to mask off each stamen. Then I spray a light green mix.

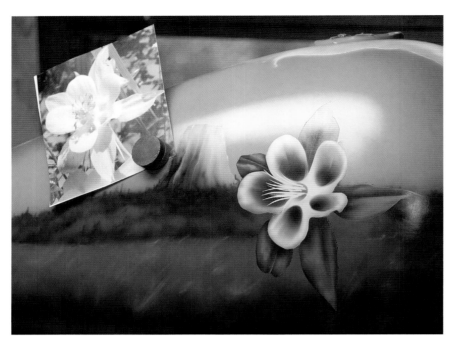

Looking closely at the reference photo, I notice the area under the stamens is darker than the area surrounding it. So I spray some thin black and then some thin transparent purple. But now I have to redefine the lighter raised edge. How do I do that?

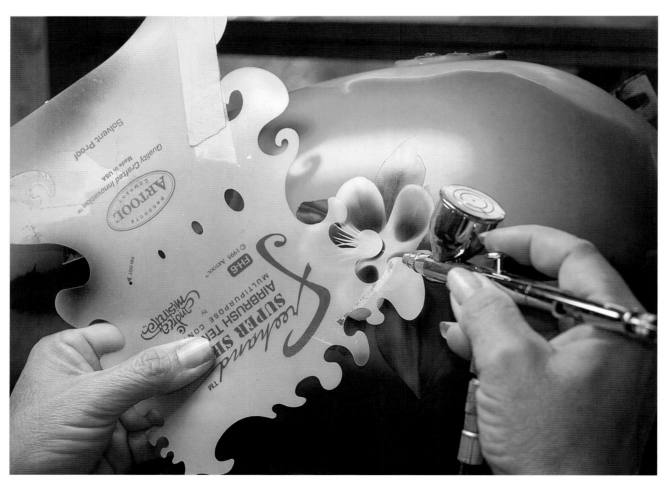

I redefine the edge by using a lobe shape on the FH-6 freehand shield and softly spraying some of the light white/purple mix.

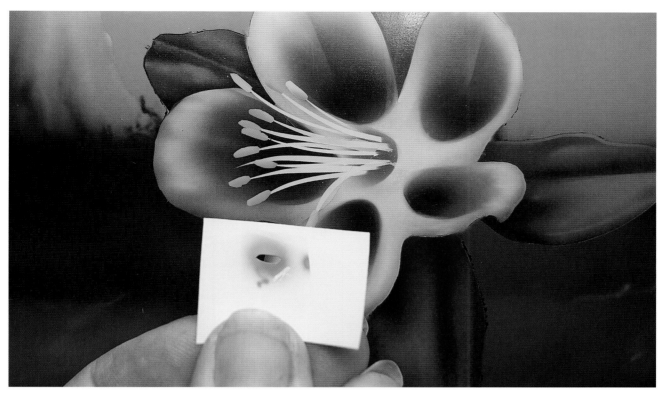

Now it's time to put the little ends on the stamens. I cut several oblong shapes out of some Gerber Spray Mask material and spray some darker green/white paint.

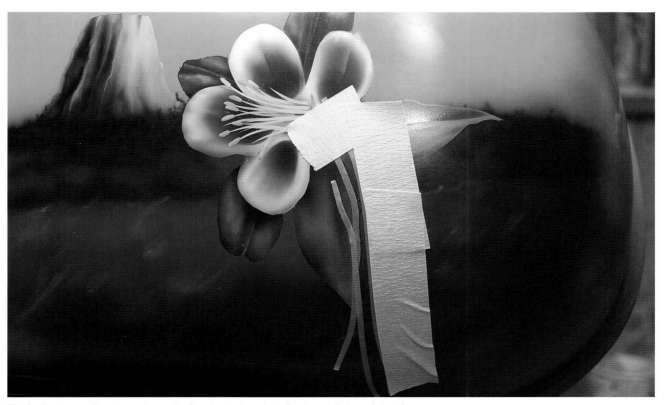

With fine line tape, masking tape, and paper, the flower's stem is masked off and sprayed using a dark red/brown.

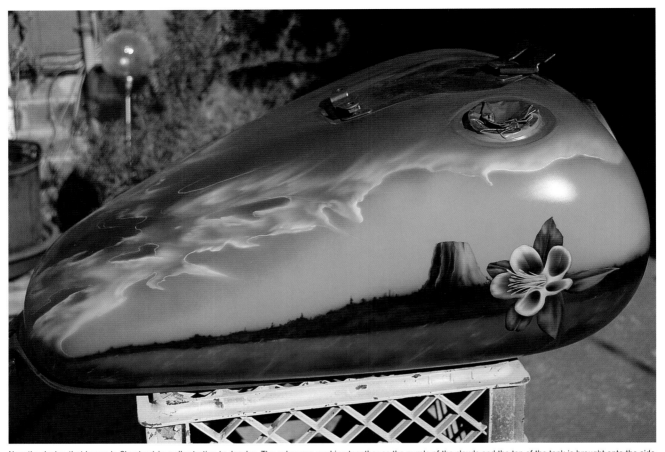

Now the design that began in Chapter 1 is really starting to develop. The colors are working together as the purple of the clouds and the top of the tank is brought onto the side with the flower. This helps keep the greens and browns of the side mural from clashing with the soft cool pastels of the clouds.

NO SUCH THING AS TOO MANY COLORS

In Chapter 1, there was a photo that showed nearly a dozen mixing cups with various shades of the colors used for the sky and background. In this chapter, about nine more were added. This photo represents only some of the colors used so far in this mural.

The point? Don't hesitate to fine-tune your colors, even if you have three mixtures of the *same* color but in different degrees of thickness. Most of the time, I'll have three different mixes of the same color, each one a thinner mixture than the previous, until I have the perfect consistency for the kind of line or shading I am airbrushing. This is why I like these little EZ Mix cups. They're inexpensive and hold up rather well to solvent-based paints.

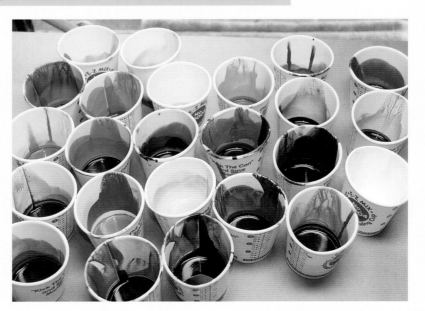

STAYING SANE

It's all too easy for the airbrush studio to get messy. Every surface seems to get covered with clutter—reference photos, books, drawings, various pieces of paper. Essential bits of stencil stuck everywhere. Plastic freehand shields laid out so you can quickly pick out the one that you need. Then there are deadlines, and time is not always taken as needed to put things away. You stop the action to work on another mural, and suddenly you see you are surrounded by mess. Take the time to organize as you go, or *try* to anyway. It's always a good idea to take a break from the airbrush and give your hand a rest. Use that time to put away anything that you will not be using that day. An artist needs space, and yet there never seems to be enough. With so many reference items and tools in my studio—from books to files of drawings and stencils, to animal skulls, to bins of airbrush parts—it is all too easy for it to get completely out of control. It always helps my frame of mind to have open space on my tool tables.

PART TWO—AIRBRUSHING A FABRIC EFFECT

Reproducing the effect of a flowing fabric surface is all a matter of using a very light touch. The best results are obtained with very few strokes of the airbrush using very thin mixes of paint. Less is more.

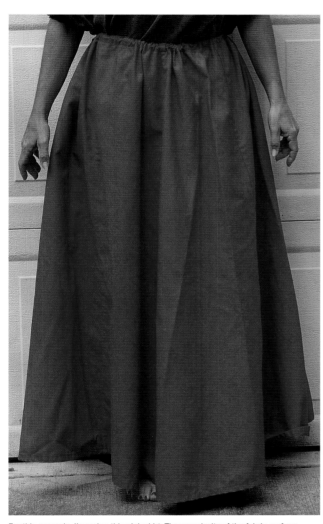

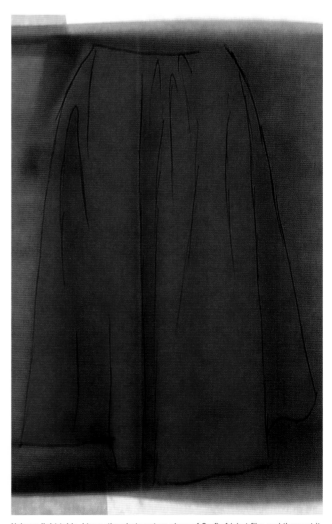

For this example, I'm using this pink skirt. The complexity of the fabric surface will have much to do with the photo I'll use. I find that the best flowing surfaces to airbrush are the simpler ones. This isn't because they are easier but because the simpler layouts of fabric folds are visually more attractive and work more effectively than a complex surface covered with folds.

Using a light table, I trace the photo onto a piece of Grafix frisket film and then cut it out with a No. 11 X-Acto knife.

A SIMPLE THING

Here is an example of a very easy-to-paint mural that turned out very sharp. The flowers were airbrushed freehand. See how they wind under and over the stock stripe on the factory paint? A slice cut into a piece of paper was used as a stencil for the blades of tall grass.

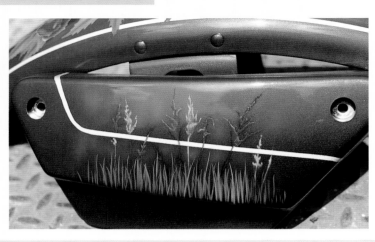

The two initial colors are mixed up and can be seen on the left. House of Kolor Pink Kandy Koncentrate is used as the main color base. The color on the right was the first color that was mixed up, but it was not used in the end. Don't get frustrated if the colors planned for the mixtures do not work out as planned. Put them aside and start fresh.

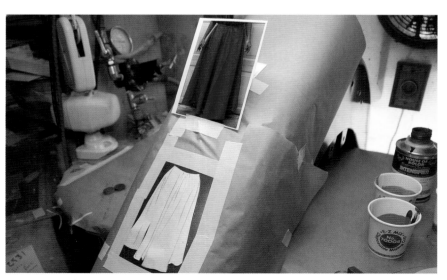

The stencil cutout is placed on the surface, and the stencil is cut out and put in place around it. Now the fender is straight up and down here, but since I airbrush better sideways, I'll turn the fender on its side. The reference photo is placed very close by.

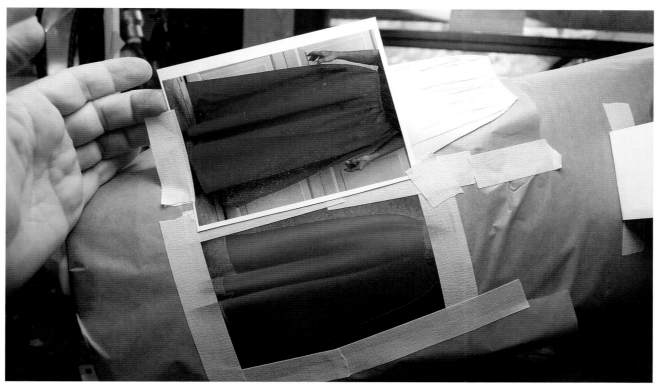

The high points of the folds are picked out. Since it will look better if it is less complex, the fold design is simpler. I make very light strokes with the airbrush here, and the paint mix is very, very thin.

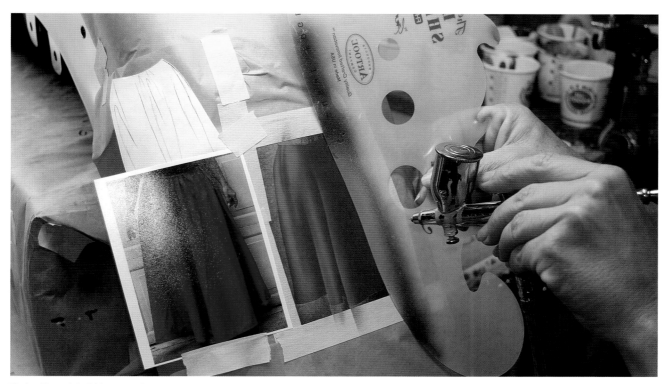

The hard lines of the folds are very fluid and natural, not straight. The Artool Freehand Shield, which is called the "Big Shield," has some awesome natural "straight" lines. These work perfectly for reproducing a flowing surface like fabric. The light pink mix is airbrushed along the edge to create a raised fold area.

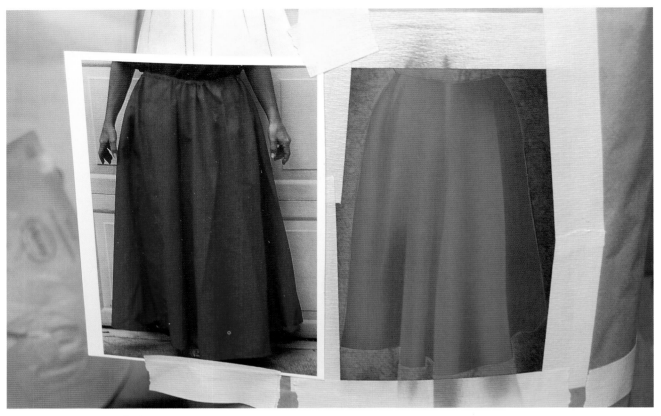

It is starting to look like flowing fabric.

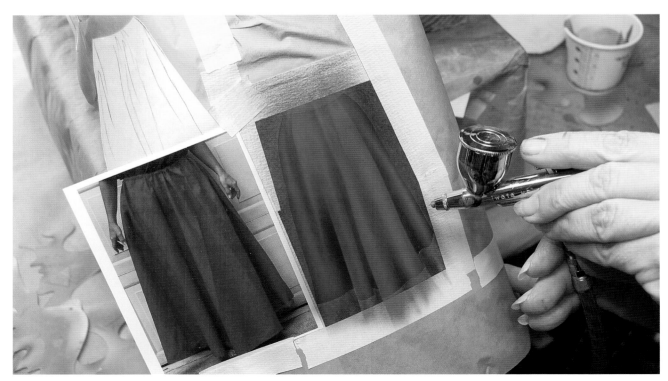

Transparent Pink Kandy is softly airbrushed in the shadowed areas. Then a very thinned-down black mix is applied sparingly.

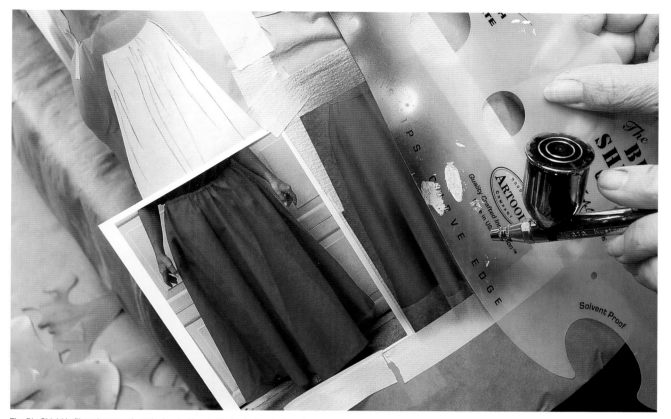

The Big Shield is flipped over and used when I airbrush black into the shadowed areas.

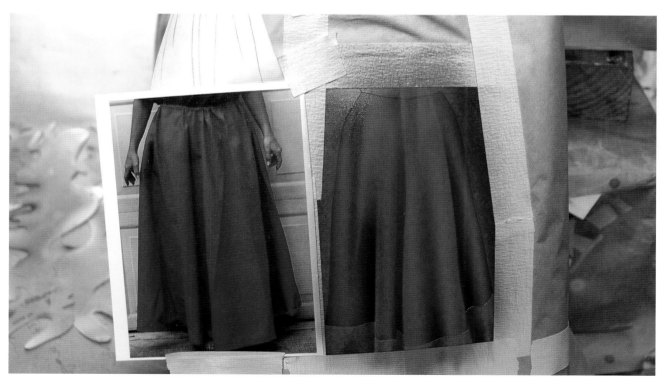

Finally, a coat of transparent pink is put down over the whole skirt. This softens up the light-to-dark transitions. Now the skirt is done.

Chapter 4
Airbrushing Feathery Surfaces

Reproducing feathered surfaces can be very easy once you know the tricks. Each artist will develop a technique that suits his or her own particular style. I find a combination of stencils and freehand work gets the desired results. Look closely at the photo of whatever kind of bird you are airbrushing. Remember, you are reproducing a surface. How does the light hit that surface? Is every feather visible? Look at the work of other airbrush artists. Do they paint every feather? Sometimes, the most effective result is not the most accurate one. Look over various photos of the kind of bird being painted. Then look at other airbrushed versions of that bird. What catches your eye?

This chapter is about how I airbrush a feathered surface. Hummingbirds are a good choice because they have several different kinds of feathers and need to be airbrushed using various techniques. As you look at the various feathers, break them down into components. Airbrush each part of the feather, one part at a time. For example, when painting an eagle with the wings spread out, you can see each feather on the wings clearly and should paint it as such. So you could say each wing feather has the components of the left half, the right half, the shaft that divides the halves, and the edges that catch the light differently than the inner parts.

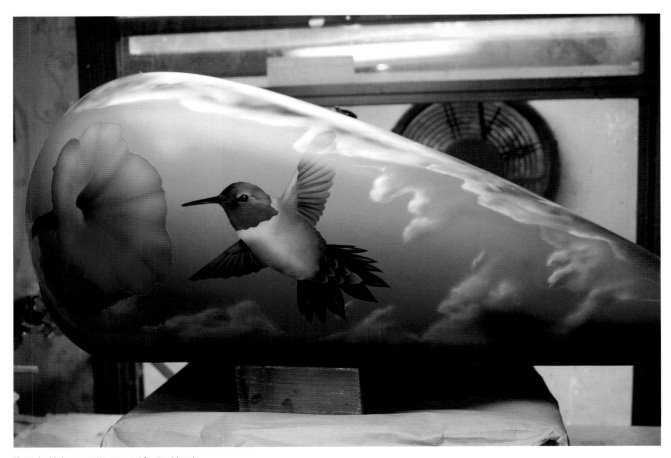

Hummingbirds are pretty easy and fun to airbrush.

Actually, when airbrushing most things, it makes it much simpler to break the item down into components. Keep that in mind when going through this chapter. This chapter also shows the final result of the mural that began in Chapter 1, illustrating how the manipulation of the elements of the mural gives the latter dimension.

Do I have a plan when I am airbrushing things like birds, animals, or people? Nope! I pretty much make it up as I go along. I think of the methods I have used in the past and try to improve them as I work through the mural. Maybe I'll even come up with a better way of doing something—or maybe not. Maybe I'll need to fall back on something that worked well in the past. The point is to keep your artwork fresh and keep improving. Try to enjoy the journey that you take as you work. Because that is what it is: a journey through the mural as you learn the tricks and techniques that will bring your ideas and designs to life. For this mural, I thought of the beauty and serenity of the high plains on a summer day, an open field with a single tiny hummingbird.

HOW DO YOU FIGURE OUT YOUR STYLE?

All new airbrush artists have another artist whose style they admire and hope to base their own style on. But how do they do that? And what if, no matter what, the work of the new artists, in their minds, looks terrible? Artists develop their style based on what works for them. For some artists like Mike Learn, Mike Lavallee, and Fitto, freehand airbrushing is the way to go, and they excel at it. For other artists like Bill Streeter and Dawne Holmes, extremely detailed stencil use is the main part of their technique. Most artists use a combination of both, leaning more heavily toward one or the other. Look at another artist's work and try to figure out how he or she did it. Then using that influence, play around with your airbrush, try out those techniques, and allow your own style to develop.

For example, I love to freehand airbrush, particularly with certain things like clouds and the surface of bone, and I am very good at it. For much of my work, though, I use a combination of stencil and freehand, with more of the emphasis on the stencil end.

Don't get discouraged when things don't go in the direction you want. Keep at it. Don't get too frustrated to try again, and again.

ESSENTIAL TOOLS

In a perfect world, everything goes as planned, and paint sticks well to the surface. Of course, this is not a perfect world, and I don't take chances. Whenever I am sticking masking tape to a multilayered painted surface, I use a low-tack tape, like 3M's green masking tape.

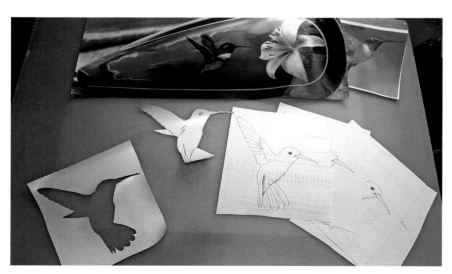

Here are the "paper" tools for the mural of the ruby-throated hummingbird. Clockwise from the top are a color copy of a hummingbird mural I did many years ago, a photo of the same kind of hummingbird I am painting now, and copies of the drawing I did for the bird. These will be used as stencils throughout the mural. Last is the actual stencil for the bird and the cutout from that stencil.

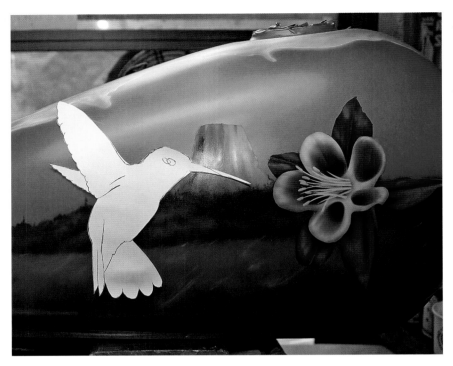

I look the mural over and decide on the best place for the bird. Because it is the main theme, I want it centered. I also consider the "balance" of the mural's design, since all of the elements need to be in harmony with each other. For example, the bird cannot be too close to the flower, but it has to be close enough to look like it is coming in to feed. I also have to consider the size I will make the bird. I want it to be as large as possible but without making it look like a giant hummingbird. Note the way the right wing tip goes over the cloud. This little detail will greatly add to the overall three-dimensional effect of the mural's design.

A SIMPLE THING

Notice how the cutout for the stencil is lifted up. It is a very narrow surface, so it will be hard to put a piece of rolled tape under it to hold it down. But I need it to be against the surface in order to properly place the stencil pieces.

The stencil piece on the top half is put into place, then the bird's beak is taped down, and the bottom easily lines up.

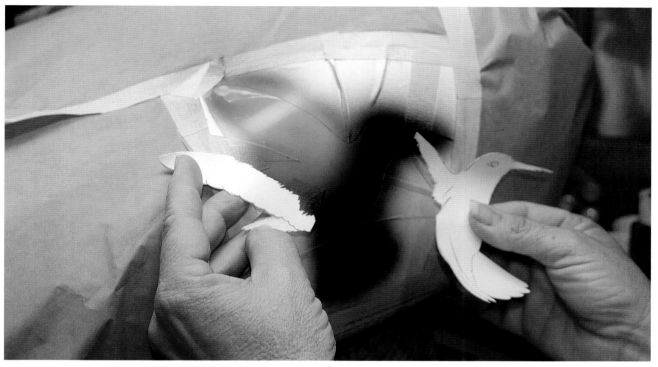

Now the cutout is starting to get cut apart. A feathery yet jagged line is drawn between the solid and transparent feather areas of the right wing. Then those areas are cut apart.

OOPS! STUPID MISTAKES

OK, know this: You will make stupid mistakes as you work. Expect it, and then fix it. For example, here I sprayed black in an area through which the background needs to show. To remedy this, the stencil is left in place, and I simply repaint the background, blue, and cloud edge in the wing area. I pull back the stencil and check and adjust the colors in order to get them to match the background.

Maybe some artists never make mistakes, but I am not one of them. So I am always prepared to fix the problems I create.

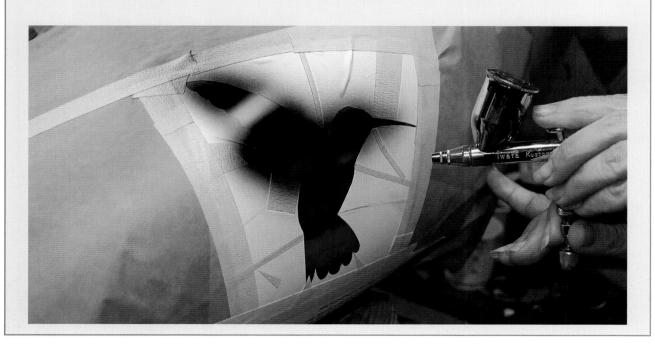

The transparent feather piece is then stuck into place on the mural. Notice how the tail section has been masked off with a paper stencil.

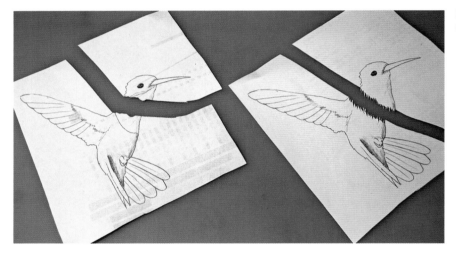

I'll go through the paper stencils and cut them all apart so that they're ready as I need them.

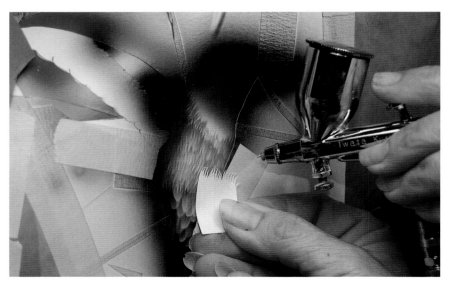

Using hand-cut stencils, I begin laying the feathers. Note that I am starting out with a light gray. Why? I want to lay out the body of the bird by using the shadowed areas to give it form. To use this method of dark and light, I need to airbrush most of the body. Since the feathers at the bottom are not green, they are all airbrushed using the gray. Note the random pattern being used.

A SIMPLE THING

One of the best tools I have for creating feather or fur effects is a simple hand-cut stencil, like these that I made for the hummingbird. The trick is to keep the cuts as random as possible and try not to line up the stencils when spraying. Don't spray across the length of the stencil. Just hit it in one place, move the stencil, spray again, and keep repeating. In this photo are some of the cut stencils I made for the hummingbird, and some I made years ago. Once I am done with a mural, I put these stencils in a file and save them to use on the next mural that requires a similar kind of effect.

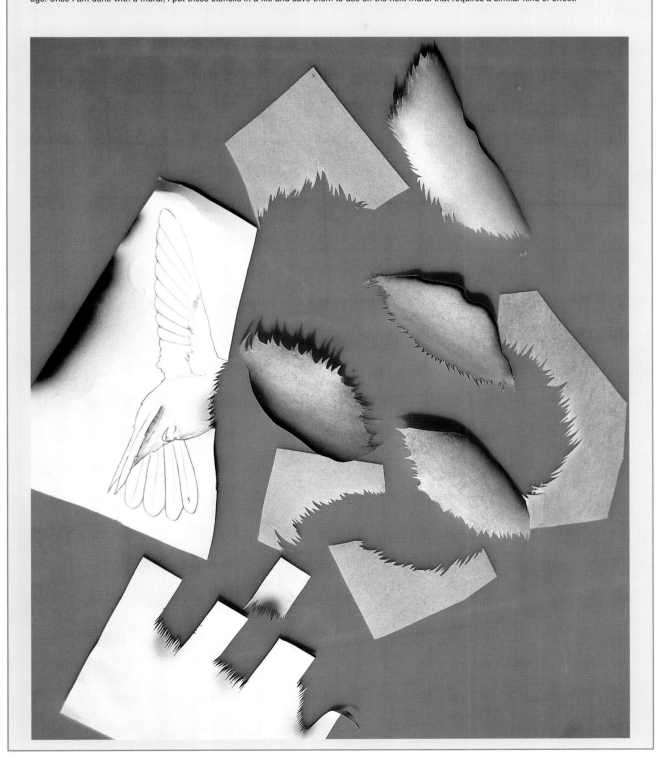

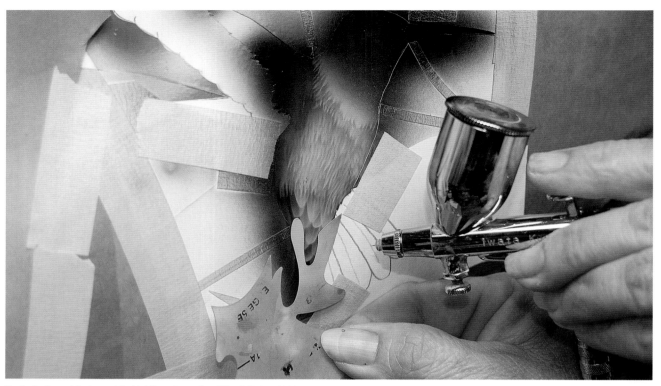

For the feathers at the base of the bird, I'm using an Artool Match Maker shield.

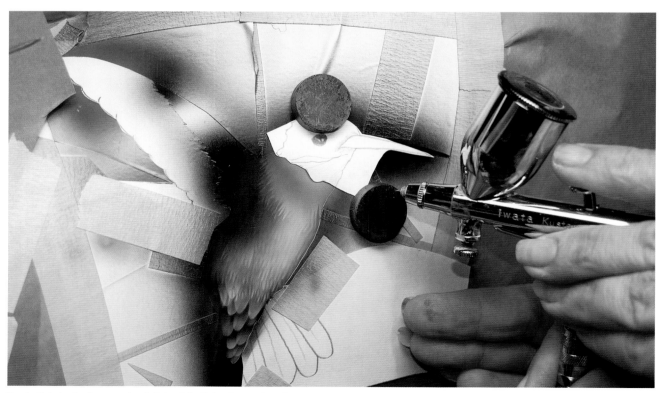

Now I will start using the paper stencils to break the bird up into sections. Here, I begin on the white section of feathers on the neck. Magnets hold the stencils in place. The stencil also masks off the head, which I want to keep black.

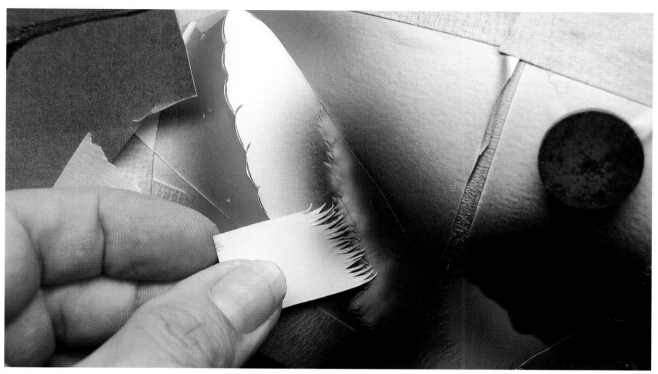

Here, I am working on the upper wing, which has three sections of feathers. The wing starts out with little green feathers, much like on the body of the bird. Then an edging of tiny white fluffy feathers borders the edge of the green ones. Next are long transparent feathers. I start out working on the fluffy white feather border using a hand-cut stencil.

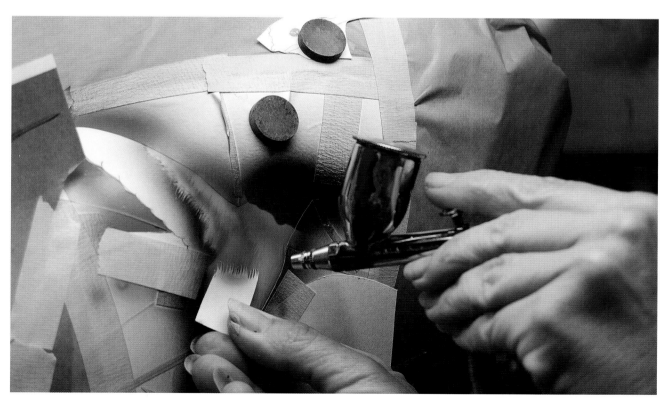

Closely referencing photos of ruby-throated hummingbirds, I start to airbrush the green feather section of the body. I spray some light green using the stencil, then lightly freehand dust on light green in random areas. I don't let the surface get too "stencily."

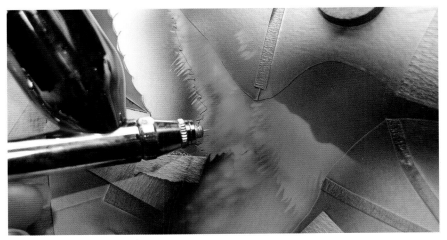

Here is a close-up that shows what I mean by "lightly freehand dust on light green in random areas," and not letting the surface get too "stencily." Note how the areas of lights and darks are starting to build up. These areas will serve as a road map, and I'll use them to keep on building up the darks and lights. All the paint mixtures I am using are very thin because I want the layers beneath to show through.

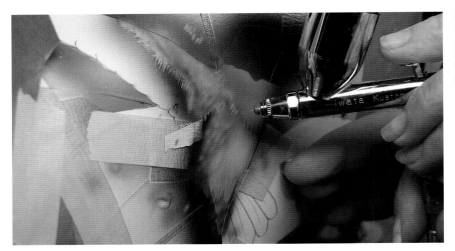

Next, I airbrush transparent green into the darker areas. I'm using House of Kolor Organic Green Kandy Koncentrate mixed into its SG100 Intercoat Clear. Then I'll pour off some green, add some black to it, and then very lightly airbrush a little of the mixture into those areas.

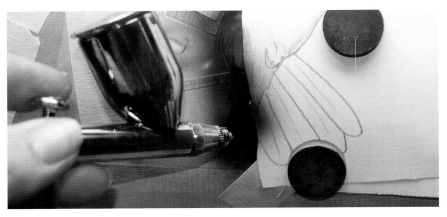

Leaving the body alone for a while, I move onto the tail feathers that directly connect to the body in the angle seen here. Referring to my reference photos, black looks to be the primary tint. Using one of the paper copy stencils, I mask off the area and airbrush in some black.

A SIMPLE THING

My first real art teacher taught me an easy way to find darks and lights—just squint and look at the picture. The out-of-focus effect will take away the detail and reduce the image to a series of darks and lights.

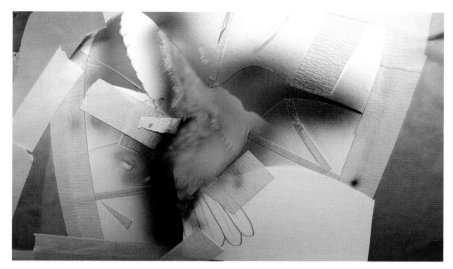

This is what I have so far. Doesn't look like much, does it? I am referring very extensively to the hummingbird photos I have. So far, this is my interpretation of a hummingbird, but yours will be different. Every artist will see something different, and the work will reflect that. I may not be too happy about what I have done so far, but I'll make a judgment call on it after I finish it. Then if it needs it, changes can be made.

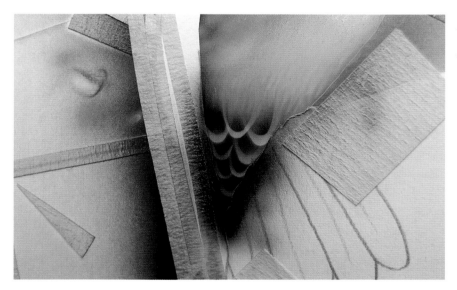

Now the black I sprayed has been masked off and the feathers under the tail have been sprayed. This is the end result. But looking at it, can you tell how it was done? How would you do it?

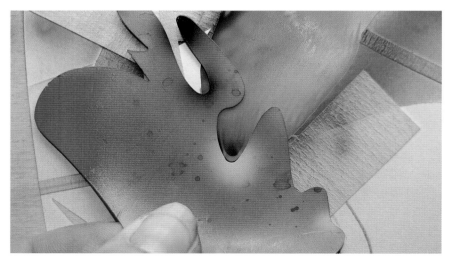

This is how I did it. Using the Artool Match Maker freehand shields, I match up the feather shapes with shapes on the shields. Starting at the bottom of the bird, I hold up one and spray a very light gray.

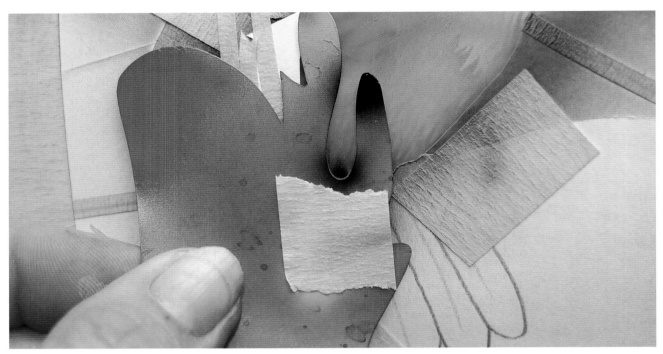

Then I find a shape that is a little smaller and line it up just above where the first shield was positioned, then airbrush thinned-down black paint. I repeat this pattern back and forth, working my way up the body until I reach the bird's belly.

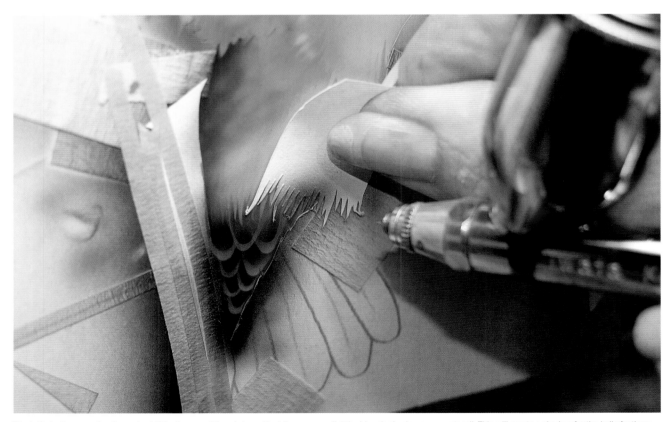

The belly feathers overlap the under-tail feathers, so thinned-down black is *very, very lightly* airbrushed using a paper stencil. This will create a shadow for the belly feathers. I keep it very random, spraying in black, moving the stencil, and spraying again. Last, some light gray is dusted along the edge of the tail feathers.

60

Here, you can see where I sprayed the light gray. But look, overspray from the black I sprayed earlier on the tail feathers ran up the stencil onto the body where it shouldn't be. I'll fix it later.

OOPS!

OK, the black was sprayed just a little too far up the edge of the stencil and got onto the bird's body. How do you fix this? Simply repaint that area. Start by making small airbrushed strokes with the darker shadow colors like dark green/black.

Then add a few light green strokes, and finish by layering with transparent green.

Now I am working on the neck feathers. Look closely and you can see where I held up a stencil and sprayed a dark gray to create shadow. Now I am spraying in white. Note the random patterns.

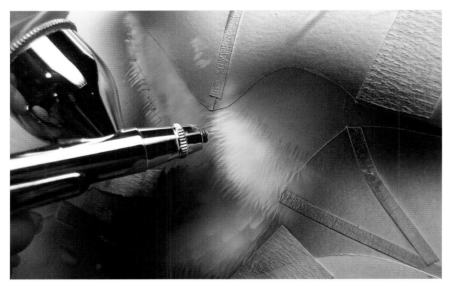

I find the lighter areas and softly airbrush white on those areas, giving the neck a delicately soft feel. Since stencils have hard edges, they can give a hard feel, as you can see on the right side of the neck. Bird feathers need to have a soft look, though, like on the left side of the neck. By freehand airbrushing in the light areas, a soft surface is created, and it softens the stencil effect just enough.

Using a paper stencil, I mask off the top area of the bird and spray black paint.

A SIMPLE THING

Overspray can be a very sneaky thing. You may be using a very low-pressure, very thin paint to shade a small area, yet once you remove the stencil or shield, somehow the paint has traveled much farther than planned. To combat this, take a look at this photo. It gives an idea of just how far overspray can travel beyond the exact location that was sprayed. In both of the sprayed spots, the airbrush was aimed right at the center, but the overspray landed and created a "halo" around them. On the left high pressure was used, and on the right low pressure was used.

So plan ahead. Use a combination of low-pressure and thin paint, and aim your airbrush as precisely as possible. Plan on the paint traveling farther than where you have sprayed it, and use that to your advantage. Never spray along a stencil or shield as far as you want the paint to be. Stop just short of that point. Allow for the paint to travel.

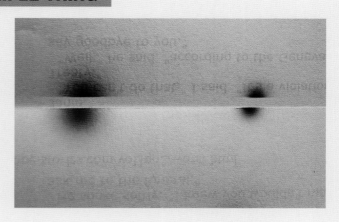

Here, I need a light fade of white to go along the length of this tape. Note the direction in which I am spraying the airbrush. By spraying at this angle, a little white sprayed at the front of the tape will travel down to the end, creating the fade I need.

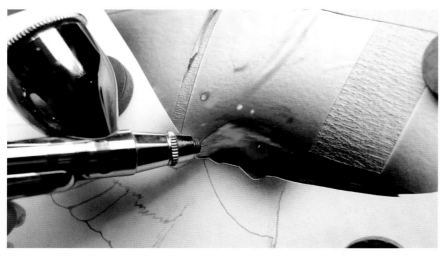

The head of the bird appears to have green, black, and dark gray feathers. Using two tones of green shaded with thinned black, I start airbrushing the green feathers on the head using a combination of freehand and stencil. I pencil in the eye to give me an idea of how to place the green feathers. Next with gray and black, I airbrush the rest of the feathers.

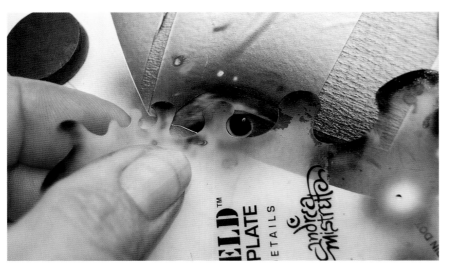

For the eye I use an Artool shield, FH-5, finding the shape that fits. First, I hold the shield one way and spray light gray.

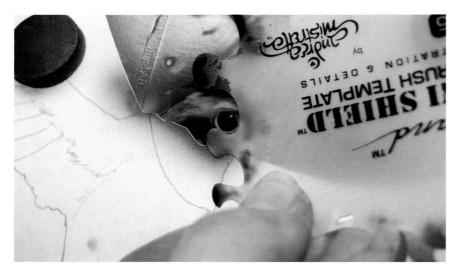

Then I turn the shield and spray light gray again. Low air pressure is used.

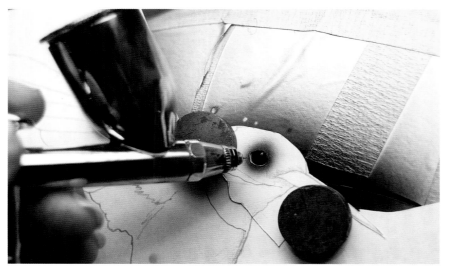

Next, I cut out the black part of the eye from a paper stencil and use it to mask off and spray the black of the eye.

A SIMPLE THING

OK, you need to airbrush a highlight on something, but you need a very small round hole, one that is smaller than anything on a circle template. Take a piece of clear transfer tape or frisket film, or anything that is clear and has an adhesive backing. Put a piece of it over an opening on a template. With an airbrush needle, poke a hole or two through it.

Next, mark where you want the highlight with a white Stabilo pencil, place the hole in the film over it, and line it up. It's easy because you can see right through the clear film. Then spray white.

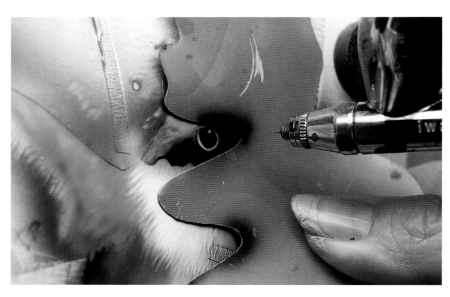

There is an "eyebrow" area of darkness around the top of the eye, framing it. Again, I find a shape on an Artool Match Maker shield and very lightly spray some black.

I spray the black very, very lightly, hardly applying any color, and it is just enough. See how I sprayed the white highlight on the eye in the sidebar.

Time to finish up this bird. The neck feathers need a little more white to soften them up. First, I use a stencil and then freehand airbrush some white. The air pressure is kept low so white overspray doesn't land on the black head.

Here's what I have so far. It's finally starting to look like something. The body is taking shape. The various textures are contrasting against each other and giving the body dimension.

Now it's time to spray the beak. The line separating top from bottom is very light, so I use very thin white and only spray it at the very front of the beak. The overspray will carry over all the way to the end of the beak, fading that line perfectly.

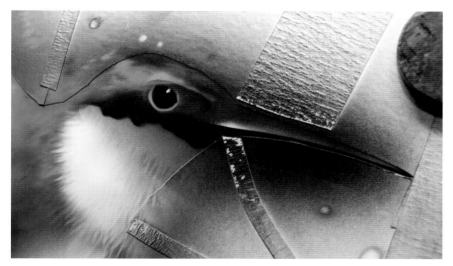

Here is the finished beak.

Now I will spray the ruby throat on this bird. I mask off the area with paper stencils and spray black.

Again, I find what I need using an Artool template. The side of one of the oval cutouts is the perfect shape for the ruby feathers. House of Kolor Blue Blood Red is mixed with some white and a little bit of House of Kolor Apple Red Kandy Koncentrate.

Once a pattern of ruby feathers is layered on, transparent House of Kolor Apple Red and House of Kolor Kandy Pink are airbrushed over it.

Now I will finish off those tail feathers. I mask them off with transparent transfer tape, which is trimmed with a stencil knife. The extra material is peeled away.

The first feather is taped off, and half of it is sprayed with black, using a piece of paper to mask the black area.

Then the paper is flipped, the other half of the feather is masked off, and gray is sprayed.

Here's what I have so far.

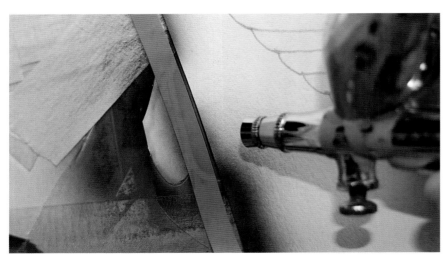

Using a combination of tape and paper, the vein that runs down the center of the feather is masked off and sprayed with light gray. Note which way the airbrush is pointing. I direct the airbrush toward the center of the line and spray, slightly directing the flow up, then down. The overspray will travel and give a nice, faded softness to the line, giving a better result than a solidly painted line.

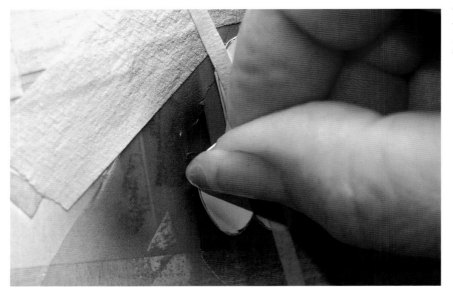

There is a lightness that edges the ends of the feathers. To airbrush this, a piece of feather stencil is placed just inside the edge of the tail feather stencil, and light gray is sprayed.

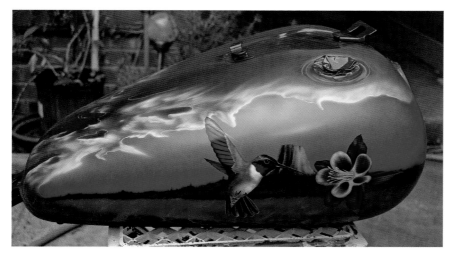

The mural needs to work from all angles, however. Viewing the tank from here, the sky really reaches down behind the bird and gives the mural even more depth.

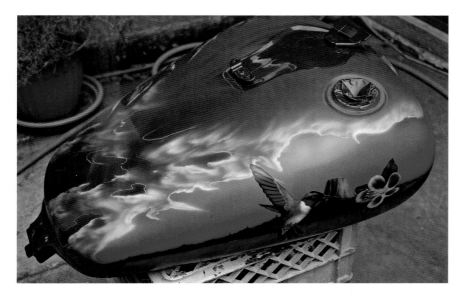

Even from the top, it works. Also, the blue sky mural doesn't take away from the "purpleness" of the base color. By having a purple columbine, the purple carries into the mural and gives a harmonious feel.

OOPS!

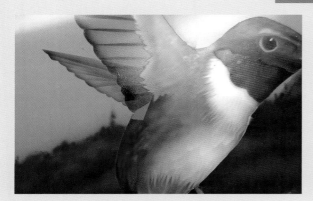

I found another flaw, where some tape covered the wrong spot. The wing needs to be brought farther down onto the body.

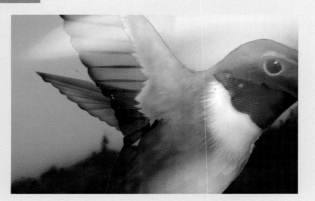

After airbrushing a little dark green and a little black, that spot perfectly blends in and disappears.

LAYERED FEATHERS

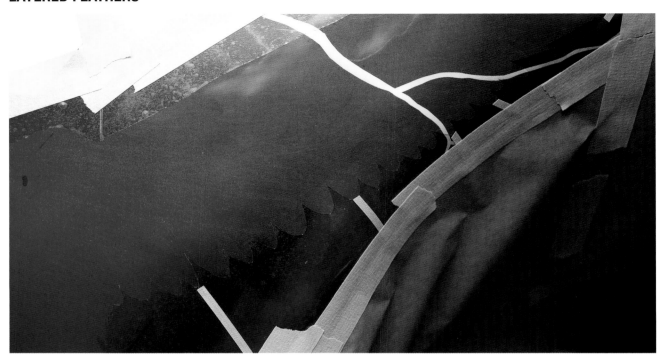

Another way to paint feathers is to airbrush layers of them. Here, the wing of an eagle is masked off. Then just enough black is airbrushed over the surface to cover it.

Next, I pick a feather at the inside of the bird, next to the body, and tape it off by running a piece of 1/8-inch 3M Fine Line Tape along the left edge of the feather. Then I mask that off with masking tape. In this photo, you can see where I have completed a few feathers and am preparing to tape off another.

Then I find the center of the feather and use an Artool shield to cover the right half of the feather. Next, I lightly spray light brown.

The shield is removed, and a little light brown is very softly sprayed over the whole feather. I airbrush a light layer of transparent brown over the feather.

Next, using the straight edge of the FH-6 Artool shield, I airbrush an even lighter brown on the left side of the feather. Flipping the shield around, I place it along the centerline so only the right side shows and airbrush a very thin mix of black.

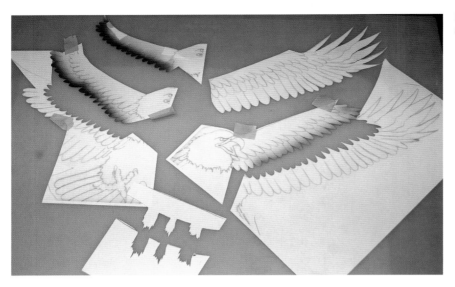

I have made several paper copies of the eagle drawing and cut them to be used as stencils, as seen here.

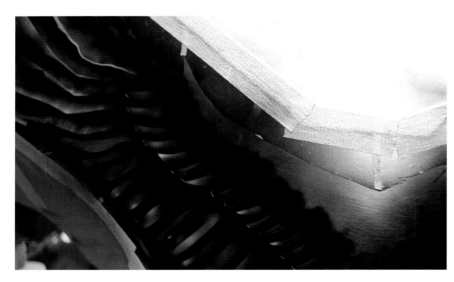

For the second and third row of feathers, I use a different technique. In this photo, I have already done the second row and am preparing to airbrush the third row. This is the end result of the next few steps in this process that I will be explaining and will help you to understand. Notice how the shading of the feathers is random. I try to make each feather a little different by varying where I apply the final darks and lights on each one. For example, on one feather I apply the last highlighting on the very tip, while for the next I apply it in the middle. Look closely to see it.

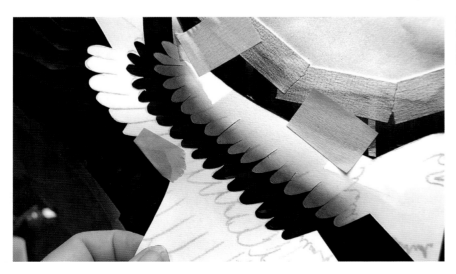

Using the paper copy pieces, I position the piece for the next row that I want to paint. Then the matching piece is placed just below the first piece. Then the first piece is removed.

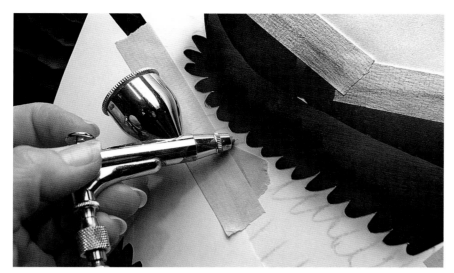

Very lightly, I airbrush some light brown and then remove the paper piece. Now the outline for the row I want to paint is visible. I mask it off by placing a piece of clear transfer tape over it, and, with a stencil knife, I trim away the area I want to airbrush, leaving a nice clean stencil around the row I am painting. Now I could just use the paper stencil, but the edges of the feathers won't be as sharp and crisp.

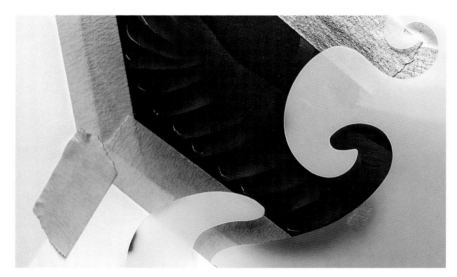

Now using the same Artool shield, I find a curve that matches the course for the outside edge of the feathers. After lining up the edge of the shield with the edge of each feather, I make one or two passes along the shield with the light brown for each feather.

A SIMPLE THING?

When painting feathers using this technique, there are two halves to each feather—right and left—but which side is overlapping varies depending on which wing is being airbrushed. The lighter side of the feather is usually the side that is overlapping the next feather. In this mural, on the bird's left wing the feathers to the left overlap the feathers to the right. So that means the right, or "bottom" side of the feather, is the lighter half. On the right wing, this is reversed. Get it?

With the straight edge, I airbrush the right side of each feather with light brown.

Using a curve on the same shield, I cover the overlapping feather and spray transparent brown, followed by a light layer of brown/black mix.

Now with the straight edge of the shield, I hold it along the center line of each feather and very lightly airbrush some thinned black.

Next, using a curve on the shield, I lightly spray random highlights on the right side of each feather.

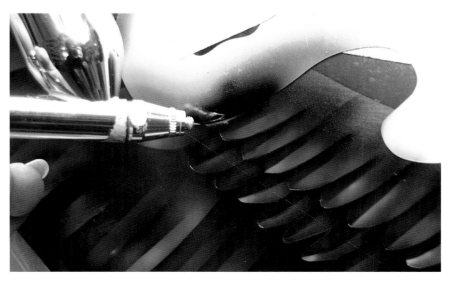

As a final step, I remove the transfer tape, line up a curve on the shield with the edge of each overlapping feather, and lightly airbrush black.

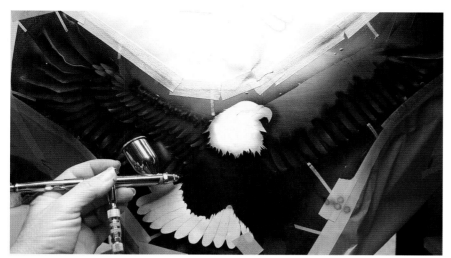

Here you can see where I have finished one wing and am making progress on the next. For the small feathers, I made long, round, feather-shaped cutouts on a piece of paper and used them as stencils. For the bird's body, I used pieces from the original eagle stencil to mask off the body and airbrushed it, applying the method I used for the hummingbird.

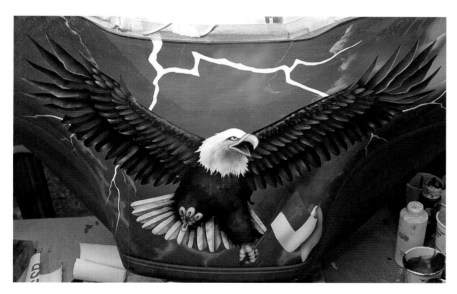

Here is the completed eagle.

Here is a another example of layered feathers, only in reverse. Instead of the darker point being where one layer goes under another, here there is a light point. Almost a glow. And it works.

Chapter 5
And Now for Something Completely . . . FUN! Airbrushing Woodgrain

Airbrushing a woodgrain effect can be fairly easy. By playing around and experimenting with various techniques, anyone can create a surface that appears to be real wood. There is no right way to do this, and unlike many other effects, the use of stencils can be kept to a minimum. Use this chapter as a guide to discover and invent your own techniques. Don't hesitate to try something different. Woodgraining is one of the easiest and most fun airbrushing techniques, so have

fun with it. Remember, though, kick back and experiment *before* you start working on the surface of your project. Use a practice piece to fine-tune your technique before you get onto the surface of your painting. Surface effects like wood, granite, and marble are some of the most stress-free things to airbrush. There's not much about this that is tedious with minute airbrushed detailing. Cut loose, relax, and free your mind to run wild and invent.

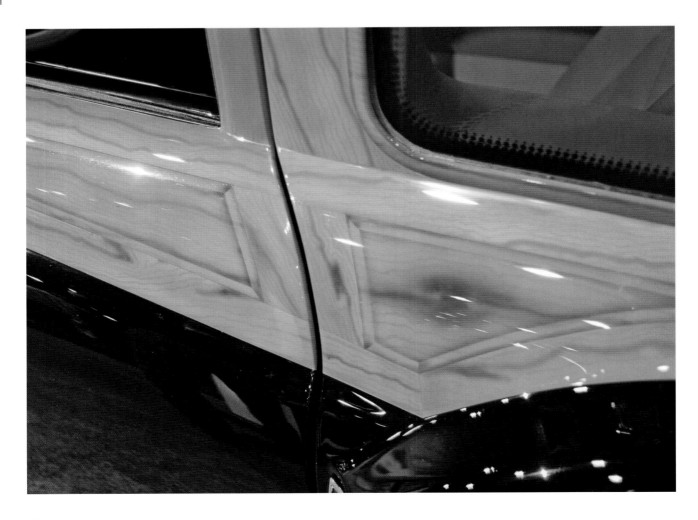

USING TYPES OF WOOD AS REFERENCE

Want to know what wood really looks like? Use photos of wood as reference. Look at the grain, the surface irregularities. Plywood has a very different appearance than the wood of a tabletop. Wood used for picture frames is different than wood used for construction. Maple has a different appearance than pine or oak. So where can you find references? Go out and look at your furniture. The tabletop in your kitchen may be different than the tabletop in the dining room. When in doubt, look around.

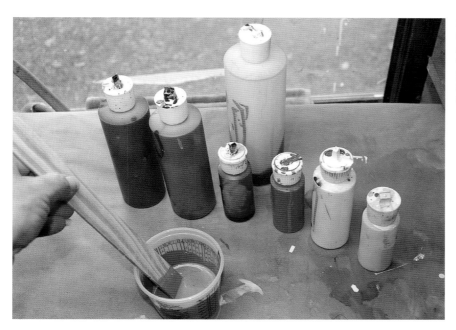

Mixing up the base color for wood is much like mixing up the color for skin tone, since many of the same colors are used. Of course, it depends on the color you want the wood to be. Here I'm going for a dark honey pine. If I was painting a light-colored wood, I would start out with a base color that had a lot more white and yellow in it.

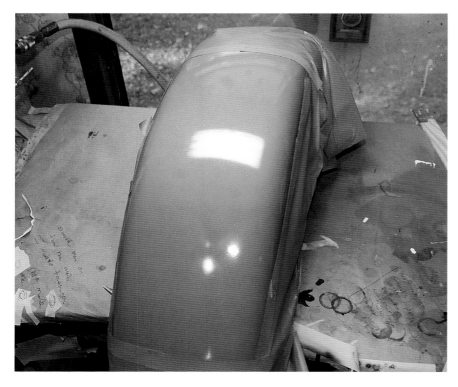

OK, here's my base color sprayed on. Looks pretty bland, huh? Not for long.

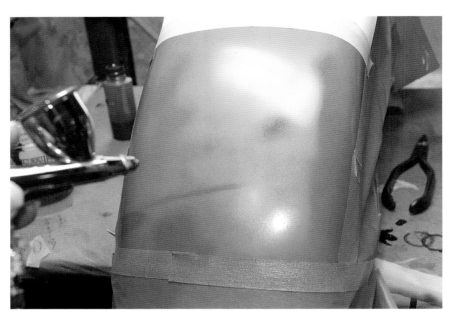

One of my favorite tints for skin or wood tone is a transparent brown. PPG calls its color DMD623, and House of Kolor calls this tone KK-11 Root Beer Kandy Koncentrate. Most paint lines have transparent colors that work great to be used as toners to tint solid colors or for use as a transparent layer. Here I use thinned-down DMD623 to lay down a transparent layer. I keep it random by airbrushing it here and there. I start to play around with laying down a line.

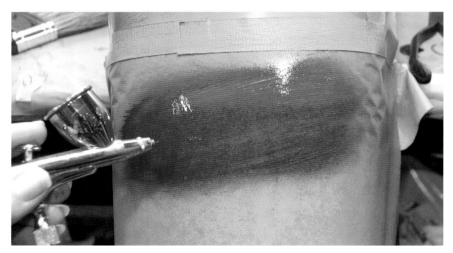

Now here's the main trick. I use a place on the taped-off portion of the fender, but any smooth lint-free surface can be used. With the transparent brown loaded in the airbrush, I spray a whole bunch of it onto the paper. Be prepared to work quickly because solvent-based paint will dry fast, and you need to work with it while it is wet.

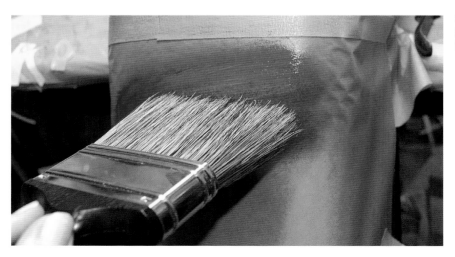

Using a large paintbrush, drag the end of the brush back and forth along the applied paint, picking it up on the ends of the bristles.

Now wipe it across the "wood" surface back and forth, or in one direction. There are no rules here, so make it up as you go along. This is where playing around and experimenting comes in, and you can use different colors. I keep my movements horizontal and will repeat this with a darker brown.

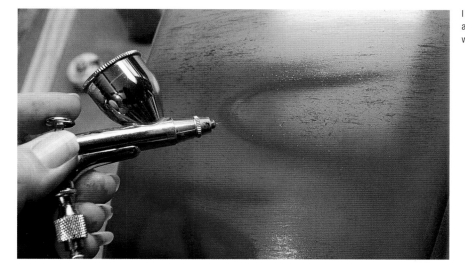

I airbrush a shadow knot in the wood, just the hint of a knot. Using the transparent brown, which is thinned way down, I airbrush the ring.

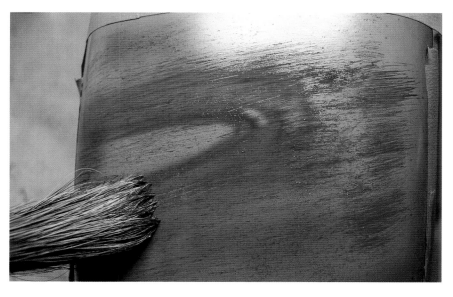

Working very quickly, I drag the paintbrush across the newly applied paint. Each time I spray an effect on the wood surface, I quickly drag the brush back and forth across it.

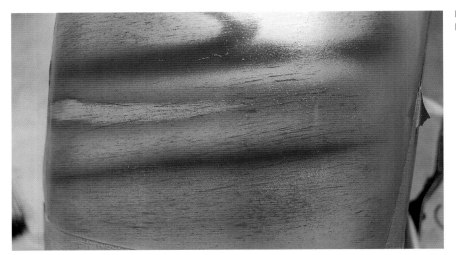

It's starting to look like wood. Wow, what a difference between what I started with and this.

Now to paint a little shadow ring in the wood. A torn piece of paper works great. I spray a light coat of transparent brown against it.

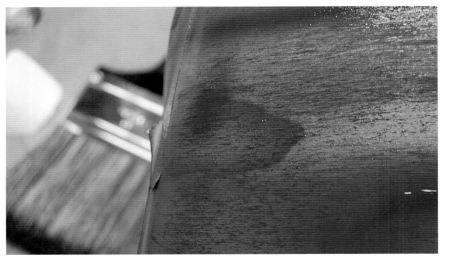

Not bad.

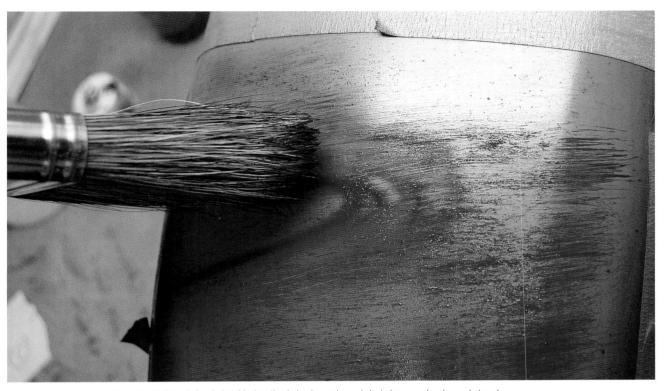

More rings are airbrushed and wiped with the paintbrush, but this time the darker brown is used. Just play around and see what works.

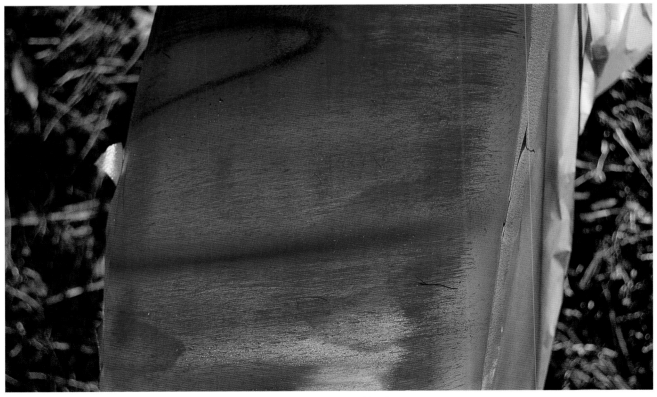

Here's the final result. Since I am playing around and experimenting, though, I think I'll try something else.

I've applied a base coat to a different part of the practice piece. Shapes are carefully torn into some paper. I'm going to try to airbrush a wooden plank effect like the appearance of a hardwood floor. I tape off a section of "wood" plank.

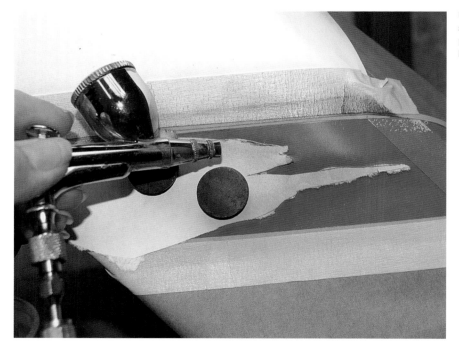

Using a magnet to hold the paper onto the metal surface, I spray the transparent brown tone along the paper. I repeat this step with the darker brown and keep the color application very light.

A SIMPLE THING

How do you get an edge that is sharp yet rough at the same time? Simply cut the shape you want into a piece of paper, but don't cut completely through the paper, just enough so that the paper will tear along the cut line. The edge will be sharp, but it will have a slight softness to it. Depending on how deeply you cut, you can make the edge as sharp or as soft (rough) as you need it. This is just something else to play around and experiment with.

I drag the paintbrush across some transparent brown and then brush it across the surface, but not as much as I did in the previous example. I'm trying something different here and seeing what happens when I keep the brush effect to a minimum.

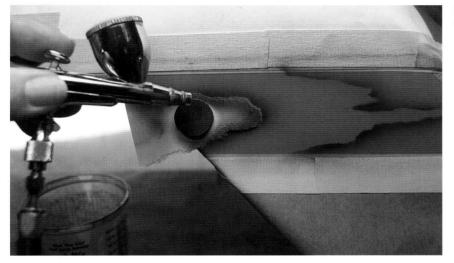

I tape off another section of plank, and here another ring is added.

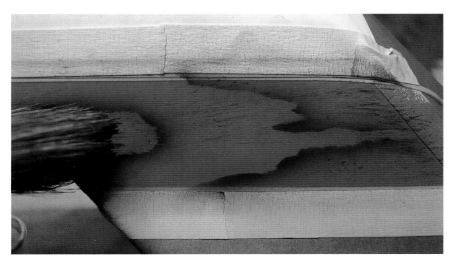

Now I add more brush effect, but just a little. This time I use the darker brown.

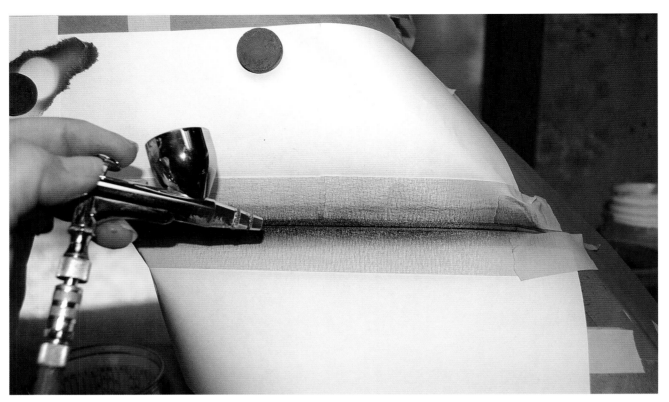

Then a seam between the planks is taped off, and soft black is sprayed.

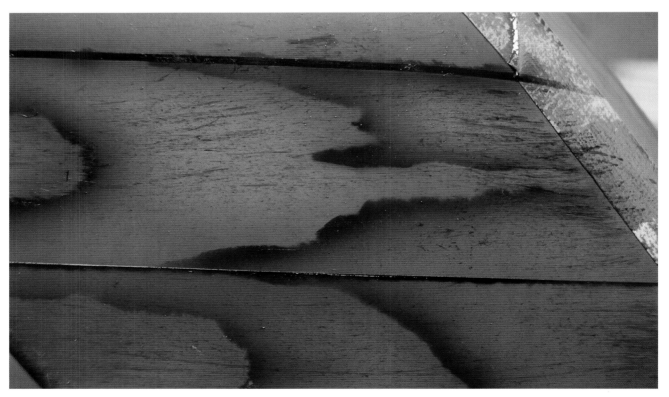

Here's a close-up of the effect.

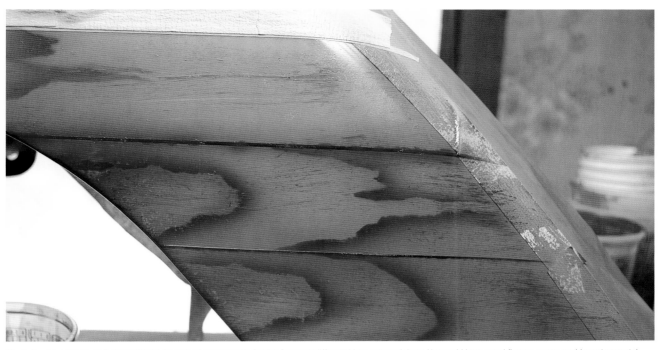

Finally, here are "hardwood planks" along the side of a motorcycle fender. So many different ideas can work here. You could have wood flames, or you could create a metal effect surface with a shape cut out of it with wood effect underneath. Let your mind play with this and have fun.

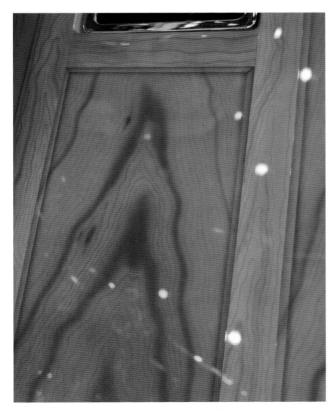

There are many other ways woodgrain can be painted. Here it appears that the artist has used only the airbrush to obtain the woodgrain effect. The lines of the wood and bevels were all carefully airbrushed.

Another version of airbrushed woodgrain. This was painted by Jeff Jackson.

The technique used for this woodgrain effect is very similar to the technique profiled in this chapter.

Here is a door seam from the same car. Note how the "joint" or seam between two "wood panels" was joined together using airbrushing.

WOOD FROM WATER

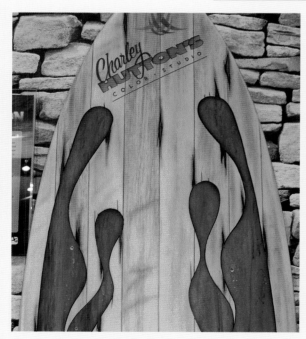

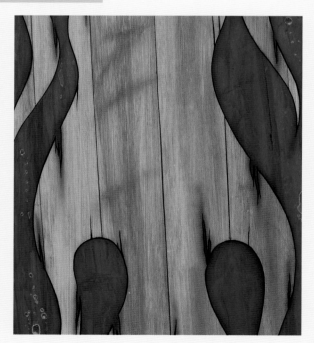

Using water-based or water-borne paint is one of the easiest ways to airbrush woodgrain. The reason? Water-based or -borne paints dry slower than solvent-based paints. This means that the paint can be manipulated much more. You can push it around, move and drag it across the surface with sponges, brushes, anything. Here is a surfboard painted by Charley Hutton using PPG's Envirobased water-borne automotive paint.

A close-up look at Charley's awesome woodgrain technique.

Chapter 6
Airbrushing Mechanical Things

The gears and hardware seen in this mural were all done piece by piece.

At first, airbrushing and painting machinery or something mechanical can seem overwhelming. Unless the artist is very skilled at freehandedly airbrushing sharp lines, most of the painting will involve as much stencil or tape work as actual airbrushing. It's too easy to look at something and think, "That's just too much." Here, the trick is to break down the components of the machinery and individually paint those items, bit by bit, working your way through until all the components are airbrushed. Another trick is to keep the lines of the components as straight as possible. Little circles should be perfect circles, not out of round.

As for replicating a metallic surface, closely examine photos of any metal surface. What exactly do you see? What colors can you pick out? White, black, various shades of gray, and maybe a blue or green with a black tone to it? While at first one would think that a metallic paint would work best, examining the colors of the surface will show otherwise. A metal surface is just like any other surface; it is made up of color tones. The *way* those color tones are arranged is what creates the illusion of a hard metal surface. The rule is always to paint what you see.

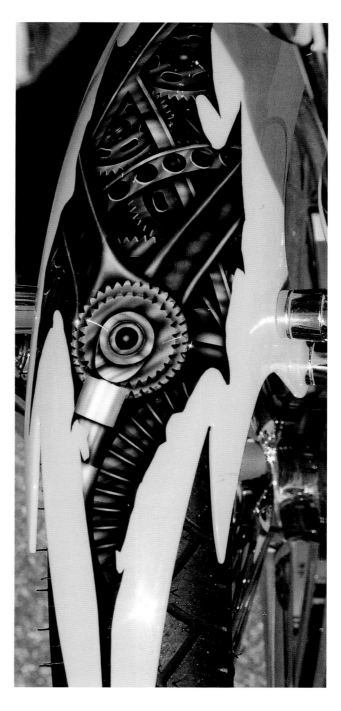

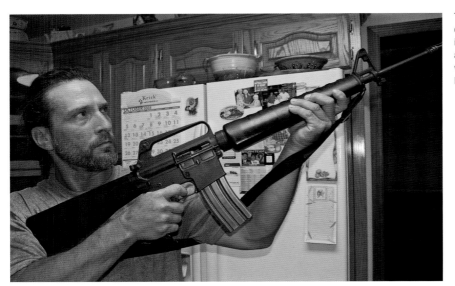

This mural features a Vietnam War theme. The customer wanted an M16 on the front fender and left it to me to design a mural around it. First off, I needed a good photo of an M16 and luckily knew someone with one. David posed holding the gun in the position I needed it to be in.

I make several different-sized copies of the original photo and pick the one that fits best in the space for the mural. Next, I place that copy on a light table with Grafix frisket paper over it and trace the gun. Because this is not something natural, there should be no natural, unstructured lines. The lines must be sharp, smooth, and accurate. I trace along steel rulers and Artool shields to draw smooth lines for the stencil. With the Artool shields, I simply match up a curve in the photo to a curve on one of the shields. Here, I am using the Bird shield to draw the line of the cartridge that holds the bullets.

A SIMPLE THING

Like most airbrush projects, the biggest obstacle to overcome is the artist's mental approach to the project. To have a positive attitude when starting a project is the best tool in your studio. Sometimes an artist will take on a project, but when it's time to actually do the work, he or she thinks, "Wow, what was I thinking? How can I do this?" Look at a project and think your way through it. How you can make it easier? Sometimes it helps to make a list detailing the steps that are needed to get through the painting, as in what will be painted first, then second, and so on. Then think about it. Create a strategy that will work for you. Don't "paint" yourself into a corner.

A SIMPLE RULE

Want something to look realistic? Keep in mind that the better the photograph from which you reference is, the more realistic your artwork will be. Take the time to get good photos, because it will be well worth it every time. If you are taking the photos yourself, don't hesitate to take a lot of them with the objects in different positions. This way you have the freedom to choose which perspective works best for the mural.

The gun stencil is cut out, and the cut-out piece is positioned on the fender. I move it around until it I find the spot where it seems to fit best. With pieces of rolled tape, I secure the stencil to the surface of the fender.

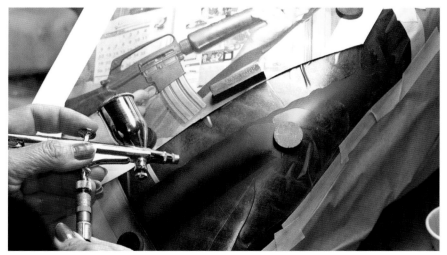

I cut the stencil apart and put it into place around the cutout. Then the cutout is removed and the rest of the area is masked off. Next, I take a copy of the gun photo and put it directly on the fender, just next to where I am airbrushing. This makes it very easy to reference from the photo to the artwork. The colors are mixed up: white and black plus a touch of blue tint create gunmetal gray. I mask off the barrel of the gun and, using my Iwata HP-CS, airbrush some dark gray back and forth to create a high point on the round barrel. Note how the hands are masked off. I cut the hand portion from the stencil cutout and use that to mask off the hands, since they will be the last thing airbrushed.

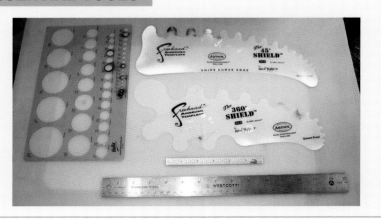

ESSENTIAL TOOLS

For this mural, straight, smooth edges are a must. I will be using circle templates, steel rulers, and Artool shields. Artool's 45-degree and 360-degree shields are real timesavers. With the tools seen here, I should be able to match up nearly every edge in this gun. I'll use these to draw straight lines and circles on the stencil, among other lines. They will be used as stencils themselves as I am airbrushing. Note the paint on the shields.

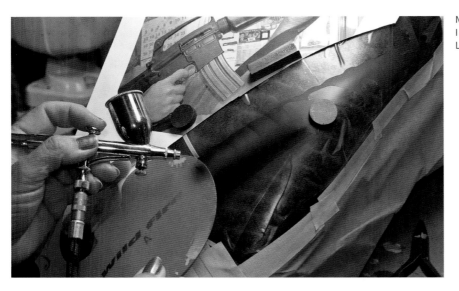

Now the barrel has ridges that run across the top. I airbrush black along the curve of an Artool Mike Lavallee True Fire Shield.

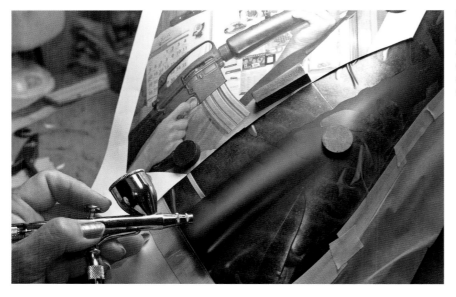

Now a black shadow is airbrushed along the barrel under the gray. Some gray is poured off into another container, and a little white and some reducer are added to it. I lightly airbrush this under the black to create form on the bottom of the barrel. Then I softly airbrush it over the darker gray on top of the barrel to give it more form. Now the barrel is done.

A SIMPLE THING

Make copies of the reference photo and use them for stencils. Simply cut out the areas you want to mask off. For many of the steps in this chapter, I use paper copy stencils. Here are the copies for the mural in this chapter.

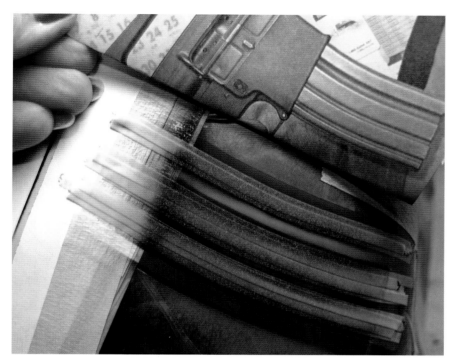

Next, the area around the clip is masked off and painted. I see that the clip is basically made up of lines, so I mask off one group of lines using 3M Fine Line Tape and airbrush this group first. The reference photo is close by, so I look at it closely and paint exactly what I see.

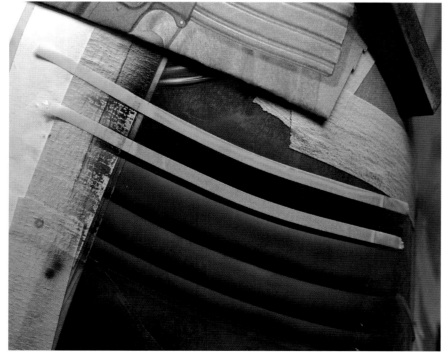

Now that layer is taped off and the next layer is airbrushed. The trick to painting grooves is to keep it simple; just paint what you see. Remember, pick out the darks and lights and paint those.

A SIMPLE THING

In order to get the most from this chapter, keep referring back to the original reference photo. I have separated the steps into the various components of the gun, so it will help to look at the gun photo after reading through every few steps.

Now I airbrush the small detailed recess in the top area of the gun using a paper copy. Because it is a recessed area and therefore lower than the surface around it, a shadow is needed. The recessed area is cut out of the copy and put into place on the mural using magnets. Then, black is sprayed along the edge, creating an instant shadow.

Next, I airbrush the raised area behind the bullet chamber. I tape this off using a combination of paper stencil and fine line tape. First, I measure the width of the area.

From this photo, you can see what I was trying to do in the previous photo. If you refer to the original photo, you can see what needs to be done for this area. This area should then be taped off using a combination of paper stencils and masking tape.

A SIMPLE THING

It's easy to get discouraged if, after airbrushing for a while, you don't see the results you want. This is why I skip around when I airbrush something like this. I pick out the easy areas to airbrush and go through the steps piece by piece. This allows me to make progress on each piece while also figuring out the best airbrush technique to use on the easy stuff. That way when I work on the more difficult areas, I am using the most effective technique.

Here is the completed area with the masking removed. If you look at the first series of photos in this chapter, you'll see what I mean by airbrushing horizontal tones. I airbrushed a medium gray and then sprayed a line of black under it and a soft black line over it. Then a darker black shadow goes across the top, followed by a lighter gray line just under that top black area. By doing these steps, you can give this area a raised curved form.

Now I tape off the handle area just above where I was working and spray a soft black shadow to give it some depth.

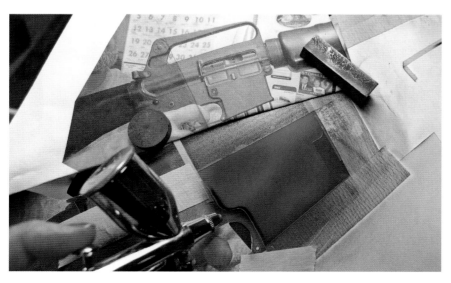

The area below the bullet chamber is taped off and airbrushed. I use very soft tones here. Note the sharp shadow along the left side. This was created by placing the paper cutout of that area just a little to the right of the edge and spraying black, creating a three-dimensional edge.

Using the paper copy as a reference, I will airbrush the screw heads in that area. First, I need to find a circle on the circle template that fits that size.

Once I find one that fits, I take that circle and place it where I want the screw head. I examine how the shadows fall on it in the photo and then start the airbrush. First, black is sprayed.

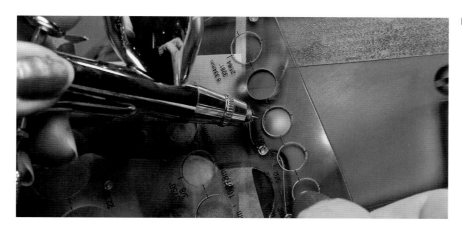

Next, white is sprayed in the center of the circle.

For the screwdriver slot, I run a piece of 3/32-inch fine line across the circle.

A SIMPLE THING

Although it has been said before in this book, it deserves repeating: paint what you see, especially if you are in doubt and not satisfied with your work. Look closely at the object you are painting. How does it differ from what you are producing? Is the shape wrong? Are the colors accurate? What about the shadows? The lights and darks? Usually when artwork is not looking like what the artist is trying for, the problem is something simple. Don't over-think your project. Approach it from the simplest angle.

Next, 1/8-inch fine line tape is run along each side of the 3/32-inch tape and then the latter is removed.

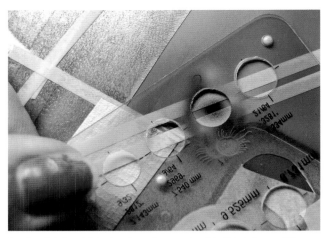

Now the circle template is placed over the screw head, and black is sprayed in the center of the circle. Why the center? Look closely at a screw head slot. It is not a solid color all the way across. By having a varied tone, it has a more realistic look to it.

Here is the finished screw head.

Now, I move back up to the handle area. A light reflection hits the top edge of the gun just under the handle opening. I tape this off with 3M Fine Line Tape.

This is masked off, and a little light gray is softly sprayed, but not too much. Just one pass is made.

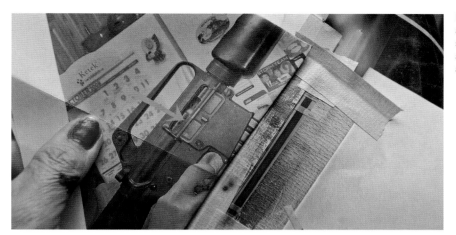

Now I mask off the rod for the chamber door and airbrush it using a back-and-forth horizontal airbrush stroke. First, I direct the light gray toward the middle and then direct the thinned black toward the top and bottom.

The area around the chamber opening is raised up from the main surface of the gun. On each end is a smooth-flowing transition to that lower main surface. While it looks like it has a sharp edge, it cannot be completely masked off with tape and sprayed. I'll use a combination of freehand airbrushing and taping to get the most effective result. The top line of the raised area appears to have a sharp edge. First, I measure how wide that is. It appears to be about a quarter-inch. Then the ends of that area are taped off and the straight edge of a template is held at the top. And using light gray, one pass is made around the edges with the airbrush.

I decide to airbrush the shadow around the raised area, so I mask it off. I start by spraying a soft black shadow to the left of the area and then lightly layer on a very light black shadow across the top. I'll do the right side later.

GO LIGHT!

Most of the colors I am using here are thinned way down, from 125 percent to 200 percent. I am using very light layers. I make one pass with the airbrush, which is another trick to getting a more realistic metal surface. By keeping the colors thin, the bottom layer colors show through. This gives the mural depth. Remember the old painting rule: it is always easier to go light and add more color than have the colors too brilliant or bold and try to tone down the boldness. Also note how I am not using white. Instead, I am using tones of gray.

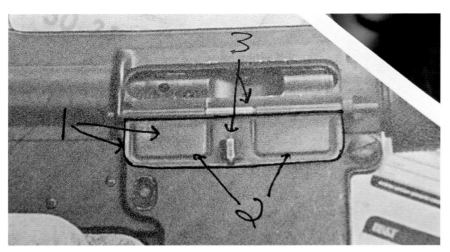

Now I will airbrush the chamber door. I start off by figuring the steps to airbrush it. The door is divided into three steps: first is the door itself, second is the U-shaped area, and third is the latch where it attaches to the hinge. Using paper copies, I cut those areas out on the copies.

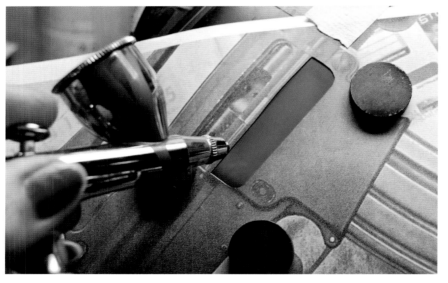

The paper copy stencil is held in place with magnets, and the overall body of the door is airbrushed in tones of gray. I use a random pattern of airbrushing that is not in any particular direction.

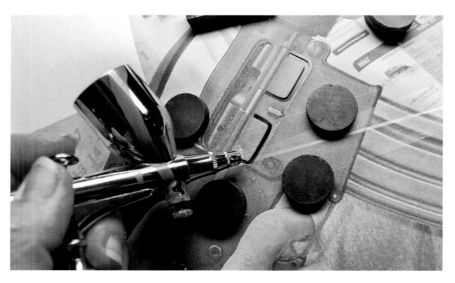

I leave that paper stencil in place, put the next stencil, No. 2, over it, and airbrush the area. This is repeated with stencil No. 3.

Now to paint the rivets on the area to the rear of the gun, I use the circle template. The right-sized circle is located and placed over where the rivet will be. Black is airbrushed, and then white in the center of the circle.

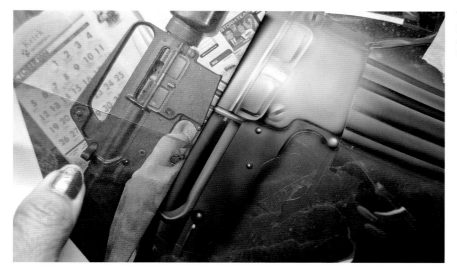

This is what I have so far. I am finally starting to feel positive about this mural and am liking what I am seeing. I also see that the area to the right of the door is too light. That section needs to be darker.

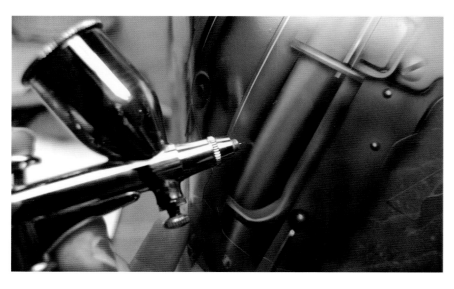

I lightly spray freehand a thin layer of black back and forth over the seam of that area, darkening it. The top of the section above that area is also darkened up. I am using very light coats here.

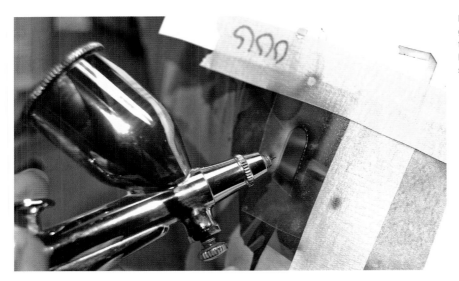

Next, I airbrush a little tab at the right rear top of the gun. A piece of clear transfer tape is placed over it. and the tab is carefully cut out. I put the piece aside, since I will be using it later. Using up-and-down airbrush strokes, I spray light gray and black over the area.

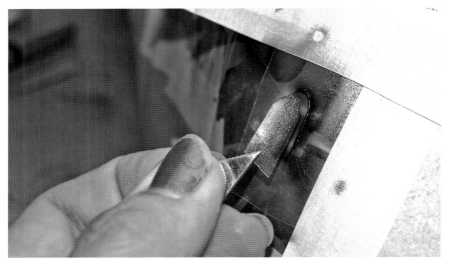

Now, here's the cut-out piece. I'll put that in, but just offset, and airbrush a sharp shadow on the bottom of the tab. Black is airbrushed. The process is repeated on the top of the section using light gray. The end result is seen in the previous photo.

A SIMPLE THING: REMOVING FLAWS

Many times, overspray will travel along a taped off edge to create a line where it is not needed. If the paint is not heavily applied, most of the time those kinds of paint flaws can be removed by literally erasing them. I use a pink eraser and prefer the pencil-top style, since the pointed tip allows for more precise erasing. One more hint: a fresh eraser surface works better than one that is dirty. So if the eraser has any material on it, rub it against a piece of paper to reveal a fresh, clean surface. Then erase the flaws. For stubborn flaws, try using a Faber-Castell Perfection 7058. This brand also makes a pink eraser pencil, the 7056.

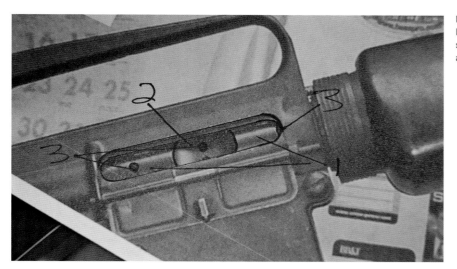

Next, the chamber opening is airbrushed. This area, like the one previously mentioned, is divided into three sections. I'll take three paper copies and cut out those areas for use as stencils.

The same technique of dark and light is used. First, I run a line of dark gray through the middle and then a thin black around the edge. A light, thin strip of light gray runs through the center of the dark gray in the middle.

Sometimes you think of the best way to do something right as you are doing it. In this case, I found that trimming and placing the cutouts (labeled section "3") in the first stencils was the way to go in order to airbrush the center section of the opening. Just a little bit of black is sprayed along the edges. Then the two black holes in that section are sprayed using a circle template.

The Artool 360 Shield would have worked as well.

Look how uneven the slot is. The left end is tilting upward.

A SIMPLE THING: CUT CLEAN LINES

The easiest way to cut a sharp line is to use a hard edge that matches the line being cut and slice against that. Here, a steel rule is being used. Artool shields and drafting templates can also be used for this purpose.

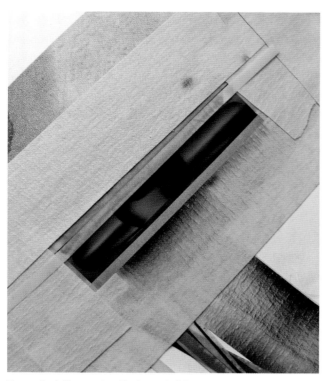

The opening in the correct position is taped off. This will help toward lining up the paper stencil.

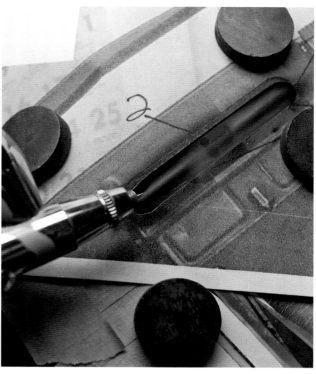

The process is repeated.

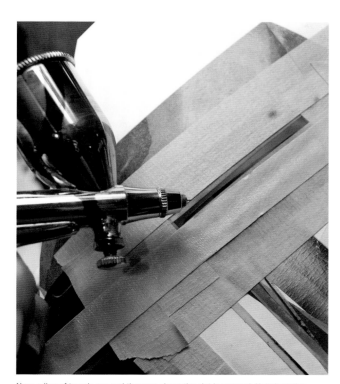

Now, a line of tape is run and the area above the slot is sprayed. Note how the original opening ran past the tape. It was that crooked.

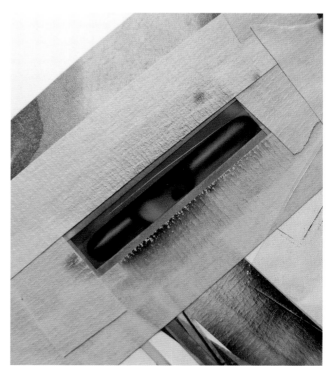

If you look closely, you can see a paint edge from the old section raised through the new section. That one slanted area would have affected the whole mural. It's a small thing that makes a big difference.

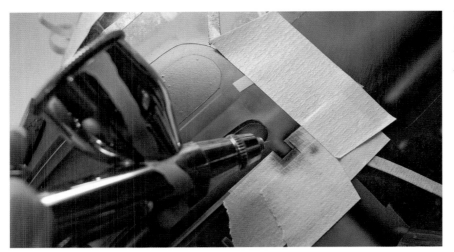

The right hinge mount for the door is painted. Look closely at the tape and where I am painting. I don't paint over on the right because the overspray will travel past where I am working and will fade in just right.

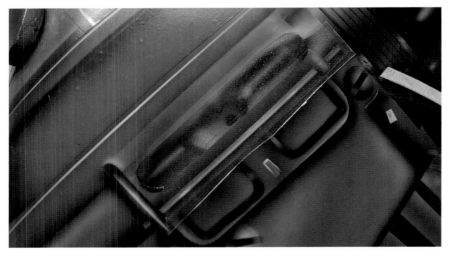

The top edge of the opening needs to be highlighted. Note how it is trimmed off with clear transfer tape. I softly airbrush a thin wash of light gray around it. Then I remove the crown cap from the airbrush. This way, I can get in close and stay right up to the edge of the tape.

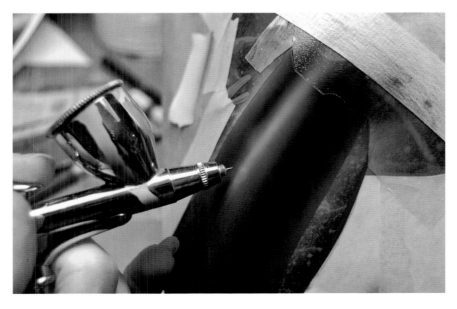

Now, the gun's stock is airbrushed.

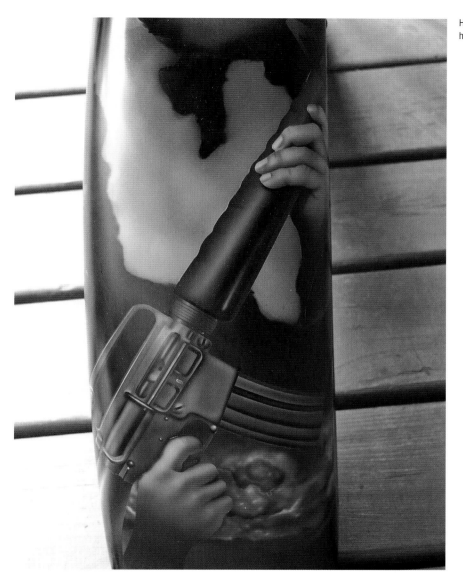

Here is the finished mural. After finishing the gun and hands, I masked them off and painted the background.

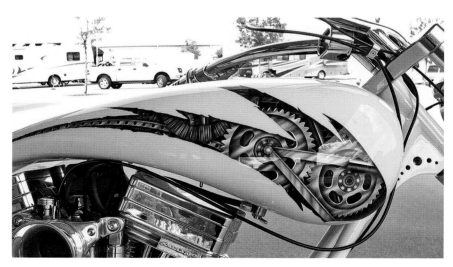

For this mural, I placed the actual gears and parts directly on the scanner and made paper copies. Those copies were used as stencils for the mural. It also was handy to have the actual part right there as reference.

IT'S RIVETING!

This line will become a seam in a surface that is painted to look like metal.

I will need two sizes of cut-out circles. Now this can be done low tech, by cutting out the circles by hand, or high tech, by using a plotter. Either way, I will need to cut out some circles to the desired size of the rivet. I'm using Gerber Spray Mask and Uncle Bill's Sliver Grippers to *carefully* pick out the insides of the circles.

Now the circle insides are lined up along the seam. I measure between each one to make sure they are all the same distance apart. Once they are lined up, I place the stencil part of the circle over it and remove the circle piece.

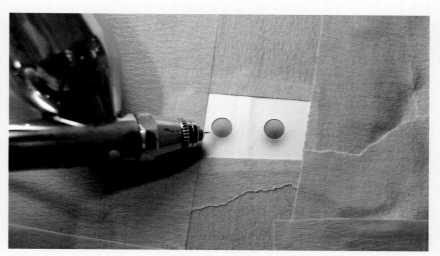

The circles are then masked off, and black is *very lightly* airbrushed at the bottom of the circle. Next, white is also *very lightly* airbrushed at the top of the circle.

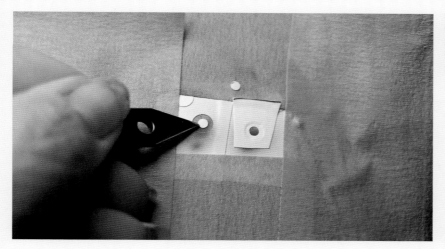

Now for second circle: I pick a size that is half the size of the first circle. These are placed in the center of each large circle, and the stencil part is placed over it. Remove the inner circle.

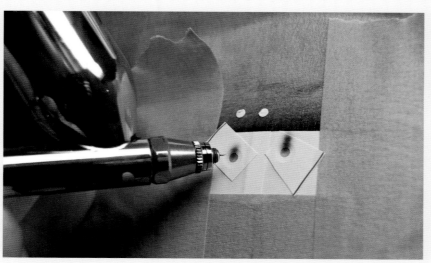

Now white is sprayed at the bottom of the small circle, and black is directed at the top of the circle. Make sure the crown cap is removed from the airbrush so you can get in real close and aim the airbrush right at the area. Remember, go soft with the airbrush and use not much paint at all.

IT'S RIVETING!

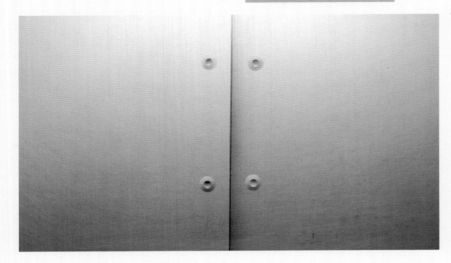

This is the finished result.

Sometimes the unexpected happens. Usually a shadow is applied under the rivet to add realism and depth, but compare these two rivets. The top rivet has a shadow, while the lower one does not. Which one looks more real? The shadow tends to soften the edge of the rivet, which takes away from its sharpness and makes it "go flat." The crisp edges of the rivet without a shadow make it stand off the surface and appear more three-dimensional.

With clear coat, the effect really stands out.

Chapter 7
Vehicles and Perspective: Airbrushing an Airplane

Airbrushing murals of cars, motorcycles, and other vehicles can be approached in the same way as any other airbrushed mural. Airbrushing vehicles involves concentrating on one part or component at a time. The real trick to getting the vehicle to look "real" is to make sure its perspective is correct. Proper perspective means to draw an image as the eye sees it. The object gets smaller as its distance from the observer increases.

Again, the rule is paint what you see.

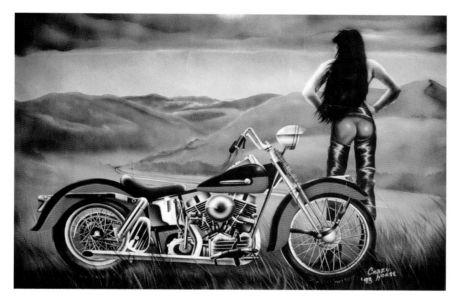

Back in 1993 when I painted this mural, I did not have the use of a computer or a plotter. Also, my airbrush skills weren't quite what they are now, but it still looks like a motorcycle. Over the years, I have learned various techniques that have greatly improved my work.

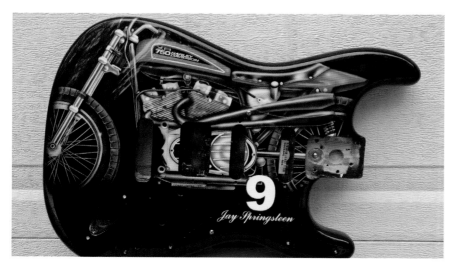

Here's a motorcycle mural I did almost 10 years later. Skills, plus using a computer and a plotter for the stencils, made a big difference.

Proper perspective means drawing an image as the eye sees it. The object gets smaller as its distance from the observer increases. When you look down a line of fence, you can see that the "size" of the fence posts appear to shrink as the fence goes back into the distance. You can notice the same illusion with roads or railroad tracks. As the two lines run off into the distance toward the horizon, they get closer together as the width of the road gets smaller. This is perspective at work.

Looking at a car from a side view, both the front and back of the car appear to be the same size.

Looking at the same car from a rear angle, the front end of the car appears smaller than the front.

In this photo, the perspective shift is even more noticeable. Proper perspective is having the correct distance between the panels along the side of this car and getting each one the right size.

In this photo, the width of the road seems to shrink as it travels into the background.

PERSPECTIVE

Understanding perspective and how it works can make a big difference in the realism of your airbrushing. Correct perspective gives a sharp, professional look to your work. Remember geometry class from high school? Perspective is all about geometry, where you determine whether planes or lines should be parallel to each other or perpendicular (two surfaces meeting at a right angle). That is, lines must be at the correct angles from each other. While correct perspective is necessary for most paintings, for "hard line" canvases like motor vehicles, buildings, structures, and landscapes, knowing how perspective works is the artist's best tool.

How does perspective work with this airplane? Look at the wings. The one closer to the viewer appears to be the same size as the wing on the far side of the plane. But about one-quarter of the far wing is not visible. Not as much wing is showing, yet they appear the same size? The reason is foreshortening. It is an optical illusion; the near wing appears shorter because it is angled toward the viewer.

Here's an example of foreshortening, as David tries various poses for the Jesus and Eagle mural shown on page 21. An arm viewed at a straight-on angle shows the entire length of the arm.

The same arm, though, when angled toward the viewer appears shorter, which is called "foreshortening."

First, I did research on the type of airplane I wanted to paint: a World War II Corsair. I looked at photos and drew one based on the customer's preferences. He wanted the plane to come out of a cloud at a 45-degree angle, banking toward the viewer at a 30-degree angle. So, I made various-sized drawings of the aircraft.

I picked the size that seemed to fit best in the space, not too big, not too small. Next, using a light table, I layered a piece of Gerber Spray Mask (low-tack adhesive-backed stencil paper for plotters) over the drawing and traced it. Then the shape was cut out and put into place on the cloud background.

OOPS!

The tail of the plane will be "ghosted" in the cloud, but it will look best if some of the solid area of the plane is over the cloud. The way the plane is now positioned will have it coming out of the very edge of the cloud. The stencil pieces are removed and carefully stuck along the edge of my light table.

I move the plane cut-out piece back so it will cover more of the cloud. Now it looks more realistic and more balanced, with the plane slicing cleanly through the cloud. The scissors point to the line where the plane will be covered by cloud.

Next, the stencil pieces are placed around the plane. The stencil had to be cut, since the surface is round and the stencil is flat, so that was the only way to get the stencil to fit. Any gaps are covered with 1/8-inch masking tape.

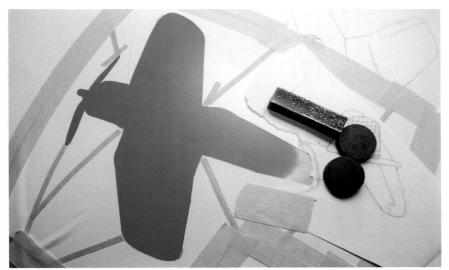

The stencil is masked and ready, plus the tail has been masked off using torn paper. The dividing line between the solid and ghost sections of the plane needs to be soft. By using a loose piece of paper, some paint overspray will sneak underneath and create a soft, indistinct line.

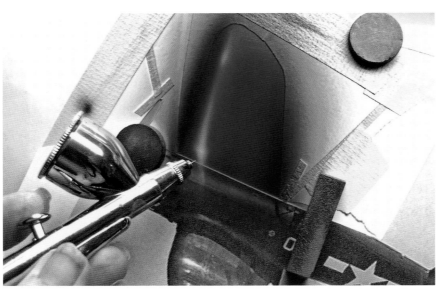

I begin by spraying darks and lights. The colors I am using here are dark blue base color, a very thin blue tint/black mixture, a lighter version of the dark blue (a little white is mixed in), white, and black. After spraying the blue base, I then airbrush in the darker areas, like along the leading edge of the wing, using the blue/black mix. This mix is very thin so it will appear transparent. Paper copies have been made of the drawing, and one copy has been made of the reference photos. I trim and use the copies as stencils. The lighter blue is used to airbrush in the high points on the wing. I keep the tones very soft, not overdone.

119

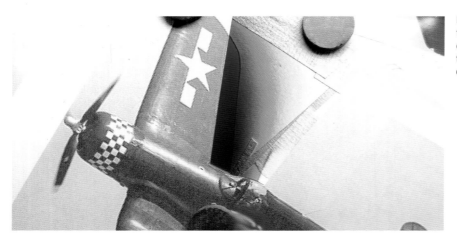

Next, the ailerons are painted. I cut along the line of the aileron on one of the paper copies and place it on the mural. While the aileron only takes up part of the exposed area, I'll run that seam down the length of the wing.

Now the area for the aileron is taped off.

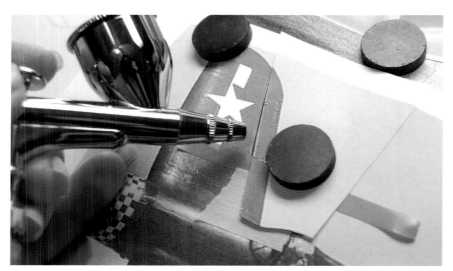

Next, I put the other piece of the paper copy into place but keep a very thin gap between the two pieces. Black is sprayed, the pieces are moved slightly to the right, and white is airbrushed.

A SIMPLE THING

One trick to creating an effective vehicle mural is to have lots of little details showing. For example, with this airplane, I want to show a few of the seams where the sheet metal of the plane comes together. But I will try to not overdo it and instead include just enough details to give it a more realistic look.

With the pieces removed, you can see the results—clean thin lines that show shadow and light.

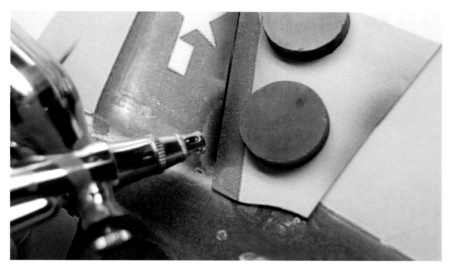

Now the seam is extended down the length of the wing using the same method. Note how big the gap is; it needs to be narrowed.

It is easy enough to narrow the gap. Removing the paper pieces, I use one-half as a shield. I line it up and uncover half of the black line by the paper. Blue paint is airbrushed. This will reduce the width of the black line so it looks more like a seam.

Now that wing is masked off, and work will proceed on the main body and other wing.

I need to determine where the transition of the main body of the plane or fuselage should be. I use a paper stencil and airbrush some blue to get an idea of where that point is. The rest of the toning will be built around that point.

Since the cockpit has a clear canopy, the background sky needs to show through it. The sky is masked off using clear transfer tape trimmed with a No. 11 X-Acto knife.

I start roughing the plane in with lights and darks, shading along the wing and body. I begin with a medium blue, then layer on a thinned-down blue/black for the shadowing.

OOPS!

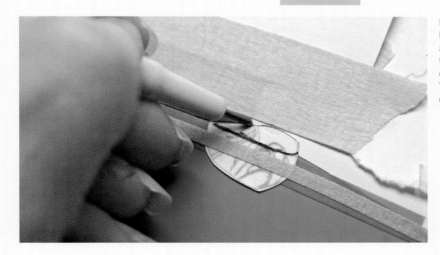

I notice the cockpit of the airplane is not nearly big enough. When comparing the drawing to the area on the mural, I realize the stencil needs to be trimmed. The cockpit is trimmed from a drawing copy and put into place on the mural. Then a line is drawn along the edge of the piece of drawing.

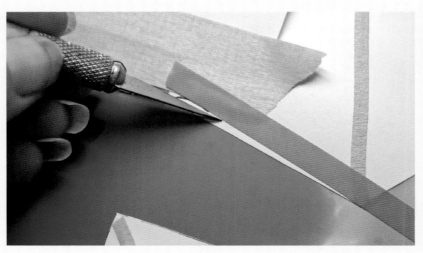

After drawing the new line, I run some tape along the backbone of the plane to the tail over the stencil material. Then using a No. 11 X-Acto knife, I trim away the excess.

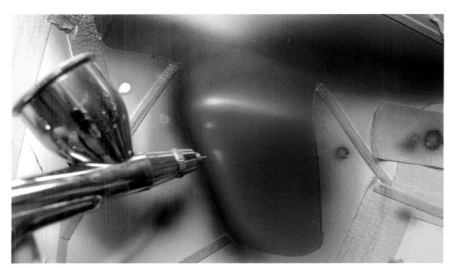

The most distinctive features on the Corsair are the angled wings, but this view from the top does not show the actual bent angle. Therefore, the wings are only shown by the highlights and shadowing. I layer on white where the bend is, then layer some transparent blue over that, and finally airbrush a very light sun reflection. I also run a dark shadow just below the reflection, giving it a very soft look. A few small highlights are painted.

Next, the back seam and the aileron are airbrushed. I cut a stencil from a paper copy and cut along the seam I want to paint.

Then, the pieces are placed on the mural using magnets, leaving a very narrow gap between the edges of the paper. Black is sprayed, the pieces are moved slightly, and a little white is sprayed.

I use the same method as before, using the pieces of paper copy to create the shadows and light reflections of the seams and aileron. This technique works wherever I want a seam.

A few more detail seams are added on the wing before I move onto the main body of the plane. I add some more light reflection along the side using a very thin white mixture. I aim the airbrush right down the center of the highlight.

Now to work on the cockpit: first I trim the cockpit area from a stencil and place it over the mural. Using a fine line marker, I trace the shape of the cockpit onto the mural.

The cockpit is then taped off and more shadowing
is airbrushed. Why is this done after the cockpit is
masked off? See the sidebar called "Defining Form."

DEFINING FORM

Think about the shape of the object being airbrushed. How does the light play across that shape? The way light reacts across a surface defines the latter's form. In this mural, the cockpit cuts into the form of the fuselage, which is hollow. How can light define that hollow space? By using contrast. To help define that hollow space, you can contrast the tone of the hollow space with the darkness of the shadow on the side of the airplane.

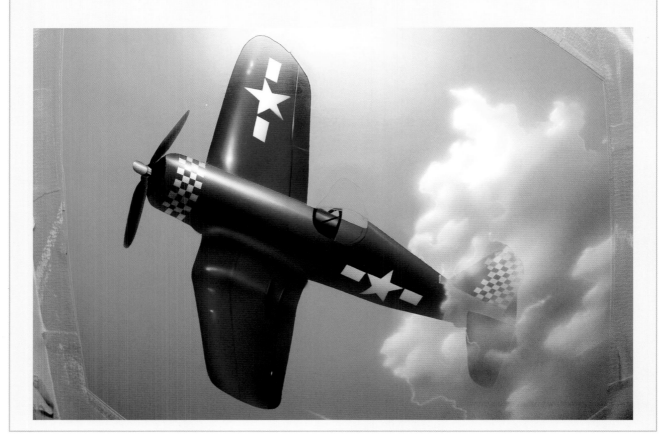

A SIMPLE THING

One advantage to airbrushing on metal surfaces using automotive style paints is that clear coat paint can be layered over the artwork to protect it. A piece of artwork can be taken to a certain point and then clear coated. That way if a mistake is made that seriously affects the artwork done previously, it can be sanded away, allowing the artist to try it again. It's a safeguard of sorts.

The next step is a matter of taping off and airbrushing the individual components of the cockpit. Using transfer tape, I mask off the area around the cockpit. Then with a No. 11 X-Acto knife, I cut along the line between the cockpit and the exterior of the body. Each canopy and cockpit piece is then taped off and sprayed. Here, the area behind the front of the canopy is airbrushed.

I airbrush a strut and then decide to wait until after clearcoating to do more work on the cockpit.

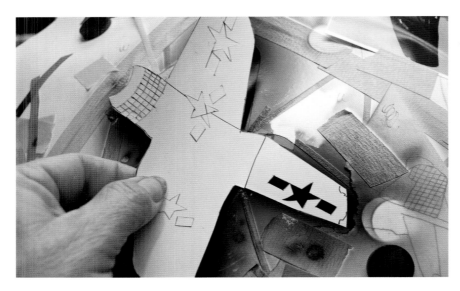

I move onto the insignia on the body and wing. The cut-out piece from the overall stencil is used as the stencil for this, making it easy to position because it fits right in place.

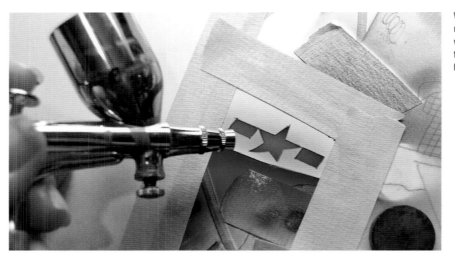

When I spray the paint for the star and bars, I keep in mind the way the shading is on the body. I mix up a white/gray mixture and softly airbrush this mix, aiming for the center of the stencil, since this is where the highlight is. This process is repeated on the upper wing.

Next, I work on the tail. I want the plane to appear as if it is flying out of a cloud with the tail still in it. So the tail needs to be ghost-like. I do this by applying the paint very thinly. Corsairs sometimes have a checkerboard pattern painted on the nose and tail. How do you apply a checkerboard pattern on the plane? Simple, the pattern is drawn onto the cut-out piece, which is then placed on the mural. The lines are lightly cut with a No. 11 X-Acto knife. Just cut into the material, not the surface below.

I pick out the checks I want to be colored and airbrush on a very thin blue *very lightly*.

A SIMPLE THING

When airbrushing ghost images, less is more. Make just *one* pass with the airbrush, then check and see how it looks. Pull back the stencil just a little bit to see how visible the line is. Ghost images are tricky because it takes a number of passes with an airbrush to create the details of an image. With each detail, more airbrushing is required, which will make the image appear more solid. One trick is to keep some background color handy, and after airbrushing in some of the image, soften it up by applying a light layer of the background color.

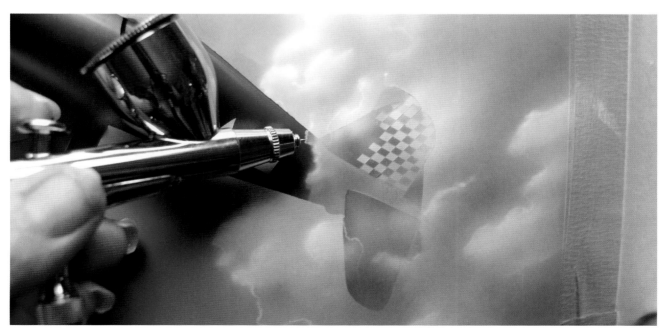

The stencil checks are picked out, and the rest of the tail is airbrushed, with each section masked off and lightly sprayed. I finish airbrushing the remaining sections of airplane and remove the stencil. Then I go over the clouds with the airbrush just by redrawing them very lightly and only in certain places, keeping it random.

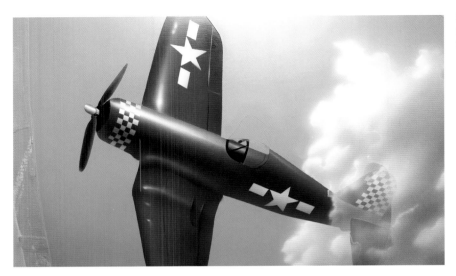

Hmm, the propeller looks as if it is standing still. It needs something. I closely examine photos of airplanes with the props turning. They have a fuzziness to them.

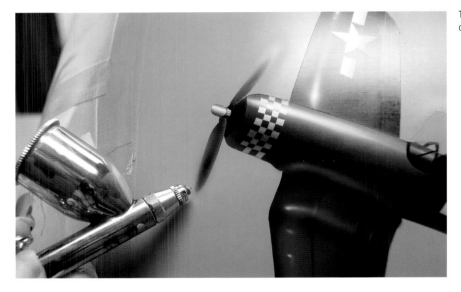

To get that "in motion" effect, I airbrush a little sky color around the edges of the prop.

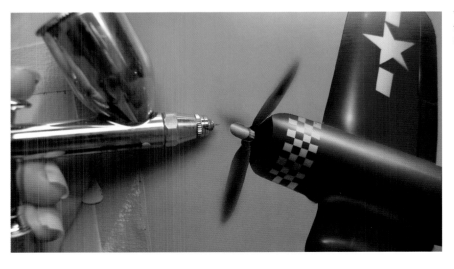

Then a little black is lightly airbrushed. Of the three blades, the farthest one will be a complete blur of motion.

It is far easier to airbrush larger images than to airbrush tiny details. The pilot in the mural is not even a half-inch tall. In that space, I have to fit a helmet, goggles, oxygen mask, and his shoulders and make them all look good. My first attempt at this did not go well. I cut the stencils out by hand and airbrushed the items. Seen here, it turned out fuzzy and amateurish. So what now?

The main thing to remember is not to get discouraged when artwork does not go as planned. Some artists get it right every time. I am not one of them, so I am used to starting over again and again. I start off by masking off the cockpit and airbrushing some medium blue to cover the poor artwork.

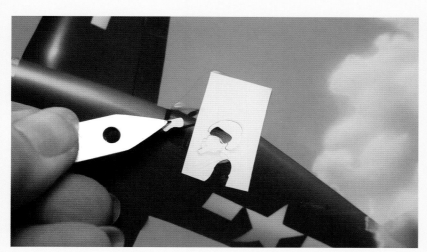

Next, I use my computer and plotter to create a vector drawing and cut out a stencil. My book, *How to Master Airbrush Techniques*, contains a chapter on creating vector drawings and using a plotter to cut stencils. Chapter 10 of that book shows how to use those plotter-cut stencils. The big advantage here is that I can make the drawing for the stencil as large as I want and then shrink it down to the tiny size I need for the mural. For example, the drawing on the computer can fill the computer screen, yet by using the plotter software, I can resize it so it is only a half-inch tall. That is exactly what I did here. This is the plotter-cut stencil for the pilot. I'm holding his goggles in the tweezers. There is no way I could cut this by hand.

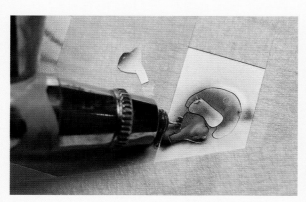

Bit by bit the various pieces of the pilot are airbrushed. While one part is airbrushed, the stencil piece is put back. Then the next one is removed and that part is airbrushed. Here, the oxygen mask is being airbrushed.

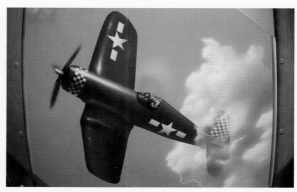

What a difference! I can see that I need to do some shading on the helmet to create some roundness, but otherwise it is almost finished.

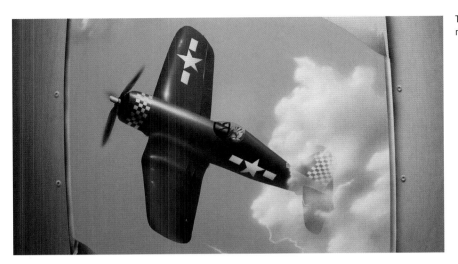

The helmet receives some very soft shading, and this mural is completed.

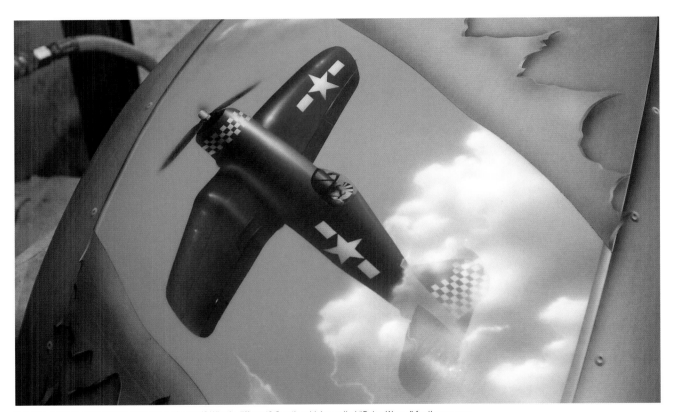

The final result: Notice how the mural was changed? What's different? See the sidebar called "Being Wrong" for the answer.

BEING WRONG

Don't be afraid to admit that your artwork needs major changes. The airplane mural was wonderful, but it was not right for the shape of the object (a motorcycle fender) on which it was painted. There was just too much blue, and the big blue square made the fender appear blocky. The mural needed to be smaller, so I changed the framing around the mural. The new size of the mural was taped off, and the base coat was re-sprayed around it.

Sure it seems like a lot of work, but the end result is far superior to the original. Make changes even if they seem like a great deal of work. This is where thinking and common sense make all the difference in your artwork. Think your way through a problem and use common sense to find the easiest solution. Sometimes, it's far easier than it may first appear.

Chapter 8
The Picky Details: Painting Hands

A SIMPLE THING

Why after spending hours on the more "important" body parts do artists rush through things like hands, feet, or even ears? Simple, they save these items for last. By that time, the artist is ready to finish the painting, so the artist rushes through the detail parts.

One solution: say a pinup girl is the mural subject, for example. I like to work on a mural one body part at a time. I usually start with the feet, move onto the legs, and work my way up. I do not move onto the next body part *until* the part I am working on is *completely* finished. That means if I am working on the feet, I paint every part of the foot, including the toenails and ankles. Until they are perfect, I do not move onto the next part.

Another solution: set a time plan for your mural. Figure how many hours or days it will take. You can set up a schedule in which every item has time to be worked on for a certain period of time, therefore making sure a day is saved for doing details like toe and fingernails, ankles, and things like that.

Nothing can ruin a perfectly airbrushed mural like poorly painted details, such as hands, ankles, or feet. Why spend the time to paint the details on a face or flowing hair but then skimp by when it comes to painting fingernails or the ridges on a knuckle? For years, artists have figured out ways to get out of painting hands and feet. They've hid hands behind hair or other parts of the body and put objects in front of feet. That is because feet and hands are not easy to paint. If one small dimension is off, then the hand or foot will look awkward and out of place. Follow along as I go through a process of painting a pair of hands.

I get my colors ready. Flesh tone is created by combining white with a transparent root beer-toned tint and then adding a little red and yellow. Various paint companies have different names for the transparent brown tint. House of Kolor calls it KK-11 Root Beer, PPG calls it DMD623, and most fine art companies refer to it as burnt sienna. I'll mix up a thinned-down skin tone, a light skin tone, thinned-down transparent brown, and a brown/black mix.

A close-up detail from a pinup girl mural.

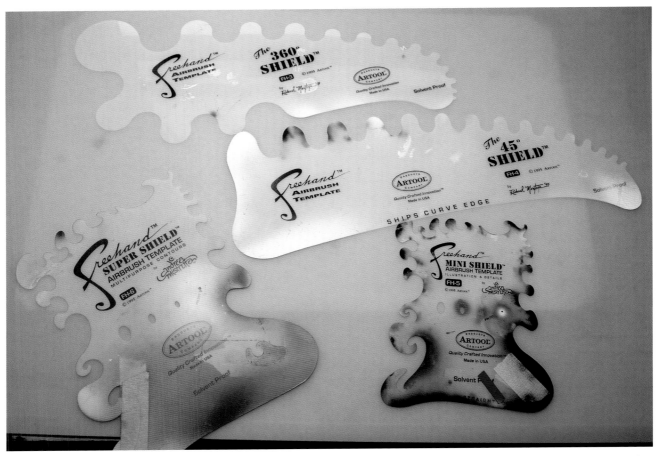

Here are the Artool shields I will be using. The 360- and 45-degree shields provide perfect half circles for nearly any round shape. The F5 and F6 Multi-Purpose Contours offer just about any other curved shape needed.

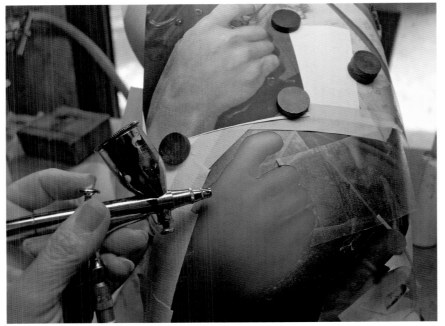

Here, I have masked off a pair of hands using clear transfer tape. In this instance, the hands are being painted into a mural that is already in process. The area where the hands are meant to be had been taped off already. This made it easy to place the clear transfer tape on the mural, draw out the hands, and then carefully cut them away. Note how I have placed a color copy of the hands I am painting right above where I am working. That way I can quickly look from my mural to the hands and paint every detail right on the money. Looking at the photo, I note the light places and softly airbrush those. See how the hand starts to take form just by airbrushing the high points (the lighter portions)?

OOPS!

Sometimes it is easy to get caught on auto pilot and start a painting incorrectly. For these hands, I *meant* to start with flesh tint, but somehow I started with white, since it was what I had been using in the previous mural. Since I caught it early, it was very simple to remedy. All I had to do was layer a thin wash of flesh tone over the white. Go over your materials at the very beginning of the painting. Make sure your airbrushes are clean and line up the colors. Have a good start.

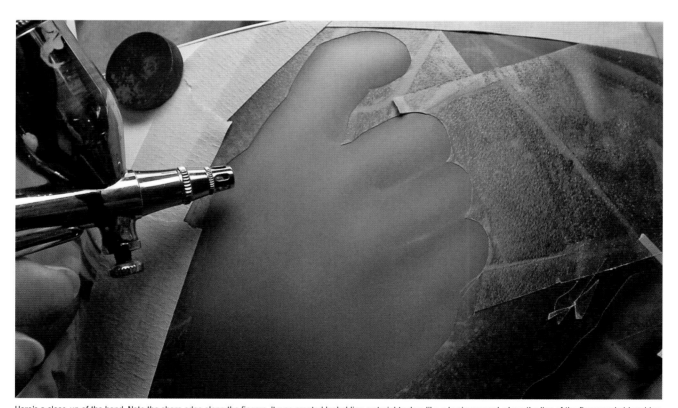

Here's a close-up of the hand. Note the sharp edge along the fingers. It was created by holding a straight edge, like a business card, along the line of the finger and airbrushing the light skin tone. In this photo, you can really see the form of the hand taking shape.

I made black-and-white copies of the hands and cut out various areas to use as stencils.

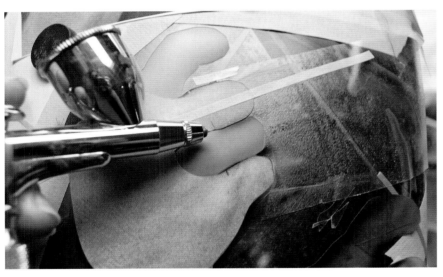

I'll be airbrushing the hand one finger at a time. For example, here one finger has been masked off using one of the paper copy stencils. See how the stencil has been trimmed back farther than it needs to be? Note how I am keeping the airbrush work area away from the left edge of the stencil and how I am directing the airbrush away from where I don't want overspray to land or it will create a hard line across the knuckle. Overspray will travel away from where I am working, and any hard edges will trap the overspray and cause a line. Doing it this way, I don't end up with a hard line where I don't want one. Here I am softly shading the shadowed edge of the finger with reduced transparent brown, followed by shading with the black/brown mix.

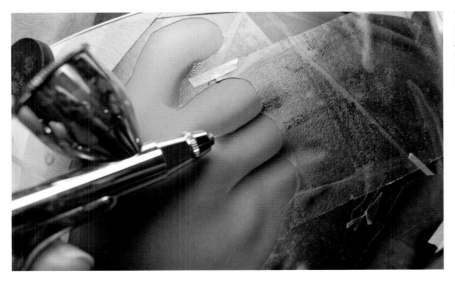

This photo really shows just how effective simple shading can be. See how the fingers are taking shape just by shading with those two colors? The bottom half of each finger is shaded with the transparent brown about halfway up. Then the top edge of the upper half is shaded.

Here's my reference photo and the airbrushed hand. While it looks good, there is a small problem developing. Do you see it?

The contour or shape of the airbrushed hand is wrong. The stencil was incorrectly cut. A paper copy is trimmed and held against the mural. The area in question is clearly seen. The overall stencil for the hand needs to be changed.

Next, the background is painted in. Because the background is black, it is easy enough to spray some black on the area using the paper copy as a stencil.

Now the shape of the hand makes sense. I can either cover the new black with transfer tape or just cover it as each finger is painted, which is what I choose to do.

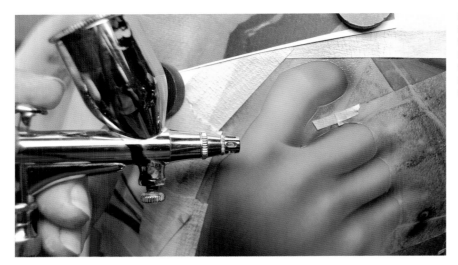

Go very light on the shading. Just a little shading goes a long way. In this photo, I've taken a little skin tone, thinned it down, and mixed in some white to use it for highlights. It is lightly applied along the light areas of the fingers and on the knuckles. Note the hard edge at the top finger. It was created by using a shield when that shadow was sprayed.

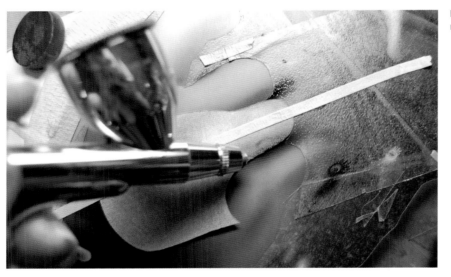

I go back and add more shadowing and just a little more black/brown mix.

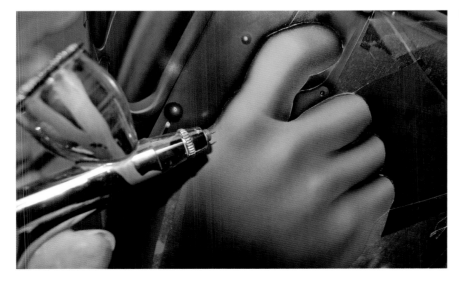

Here's the completed hand.

A SIMPLE SOLUTION

Most artists are all too well aware of their weak points. One fine artist told me his biggest nightmare was painting hands. For years he hid the hands in his paintings. Finally, he began to force himself to paint hands in every painting. He would make sure to show the hands in his model's poses when taking the pre-painting photos. When he would reach the point in the process where the hands had to be painted, he would not progress to other areas of the painting until he was completely satisfied with his work on the hands. Doing a few paintings this way trained him to paint hands, and they were no longer a problem. Plus, the accuracy of those kinds of details made his paintings better.

Now for the next hand. But what about the wrinkles? All fingers and hands have wrinkles. The first hand was wrapped tightly, so the wrinkles weren't visible, but the other hand has visible lines on it. It is very easy to airbrush them when using the right tools. I cut and trim paper copy stencils for the other hand. Notice how the fingernails are trimmed away?

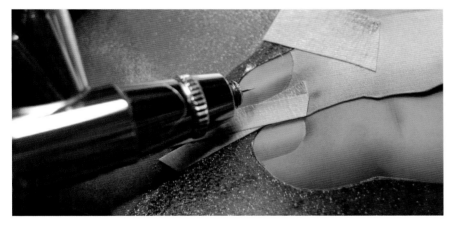

The fingers are basically painted the same way as before, with one finger masked off at a time and painted. The fingernails are painted the same way. Using the paper copy stencil, each fingernail is masked off and painted first with dark shading using the transparent brown and then with the light highlight. Compare the masked off fingernail with the unmasked one. See the shadow on the finger itself under the nail? I find a round shape that matches this curve on an Artool stencil, hold it against the surface, and spray a shadow. Using shields when spraying darks and lights makes it easy to get good results.

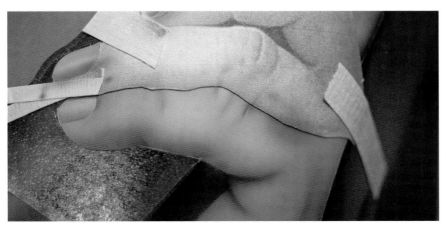

How to get those wrinkles? Look at this picture and think about it. The following photos will show how easy it was.

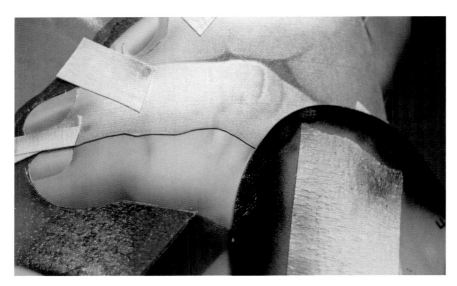

First, a shield is held up where I want the wrinkle. A small amount of brown/black mix is sprayed—just a little!

Then the reverse is done. A shield is lined up, covering the previous shadow, and pulled back so that the sharp line of the shadow is not covered. The arrow points to this area, since it is hard to see in the photo. A dark tone is sprayed to create a sharp line with a shadow on each side.

Once the shield is pulled back, the area can be clearly seen.

I make progress from finger to finger, taping off each one as I go.

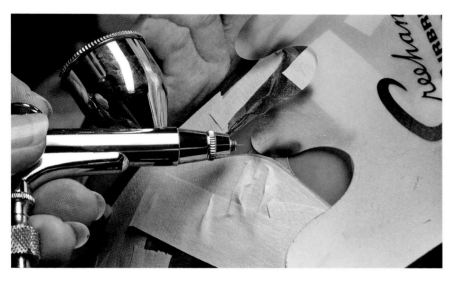

To create the folds between the sections of the bent fingers, an Artool shield is held up, and dark tones are airbrushed.

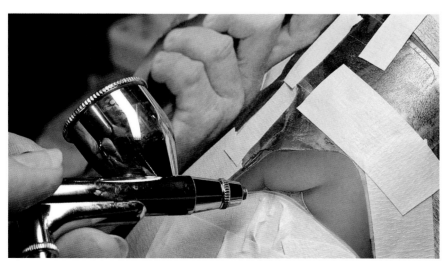

The shield is removed, and some freehand shading is done to soften and deepen up the form. Note how close I keep the reference photo to where I am working.

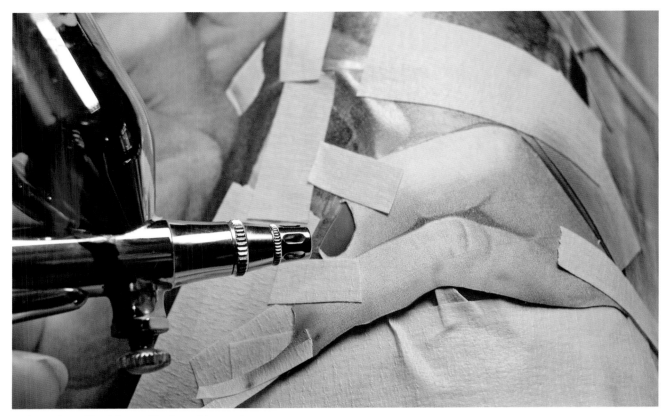

The fingernail stencil is put down, and the fingernail is sprayed.

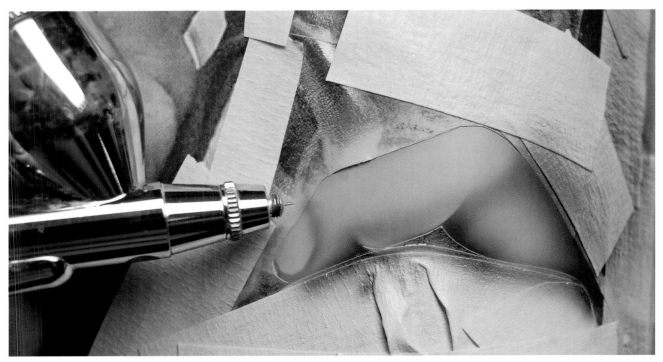

The finger takes shape once the dark tone under the fingernail is sprayed. Note all the various tones on this finger. Even if it was smaller, I would still try to paint the same way, treating is as a whole mural.

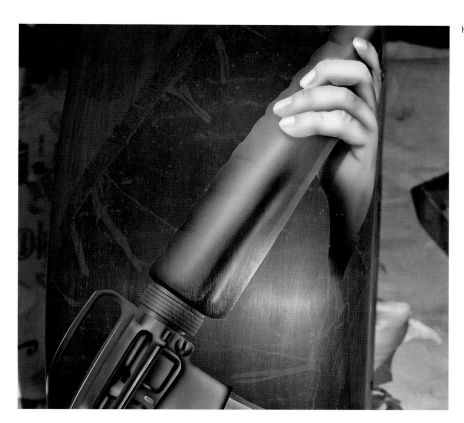

Here is the finished mural.

Look at the hands, knees, and feet in this painting. I had some pretty good reference photos for them, since they came from a combination of ideas. The shadows and highlights were kept very soft. This added to the realism.

Here's another airbrushed hand. Now this hand is extremely tiny in size, being less than an inch, so it's very difficult to get that kind of detail. Instead of trying to reproduce every line in the hand, I simply airbrush lighter colors at the knuckles. This hand is about 1/4-inch wide, but it was painted using the same technique as the much larger hands shown in this chapter.

Chapter 9
Hail to the Chief, Part 1

A reader told me about how he had tried to paint the cover image on my fifth book, *How to Master Airbrush Painting Techniques*, four times without success. So I have decided to devote a couple of chapters in this book to the process and techniques I used to paint that portrait. This will be broken up into two chapters, this one and the next, and involves techniques that have been profiled throughout all my books. I will show how all those techniques can work together.

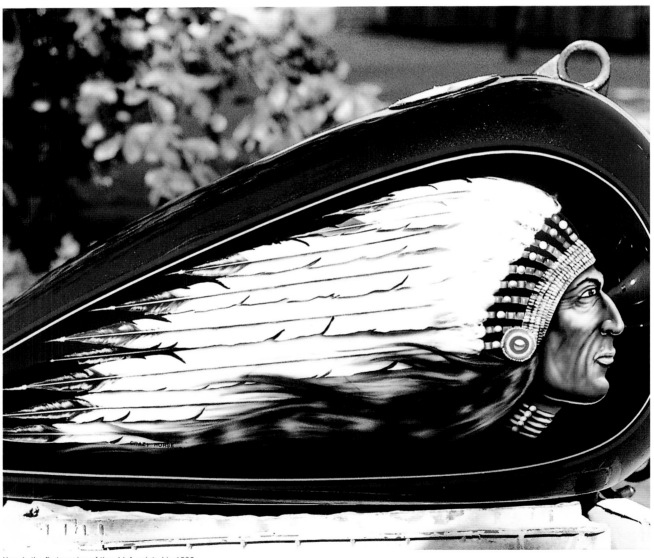

Here is the first version of the chief, painted in 1996.

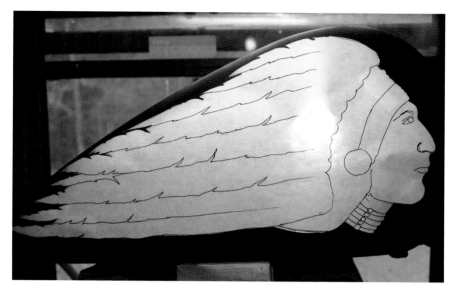

I first make a few paper copies of the chief in various sizes and find the one that fits best in the space on the tank. Next, I make a stencil of the head of the chief using Grafix frisket paper. This stencil is not too involved, since it just features the basic outline of the head and a few of the main features of the face and headdress. The stencil is cut out using a No. 11 X-Acto knife, and the cut-out piece is placed on the tank. Then I place the stencil around the cutout and mask off the rest of the tank. I also make a few paper copies of the chief to be used as stencils or shields.

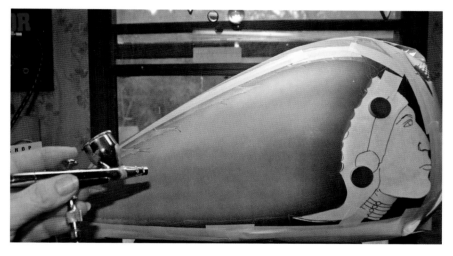

The face and front headdress portion of the cutout is trimmed off and placed onto the head, covering everything in front of the feathers of the headdress. Then a thin white mix is airbrushed.

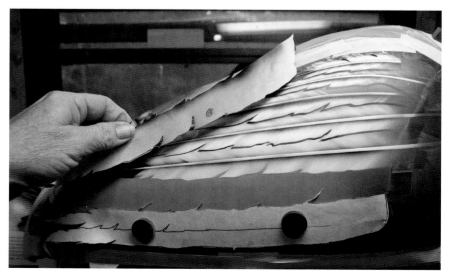

I spray one feather at a time, starting at the top and working my way down. This is because the feather on the top overlaps the feather beneath it. You can see where I'm getting ready to paint another feather. Here's where the cut-out stencil piece comes into play again. I start by carefully trimming a feather off the piece and then securing it into place beneath where I want the feather. The feather above it is masked off using the trimmed off feather.

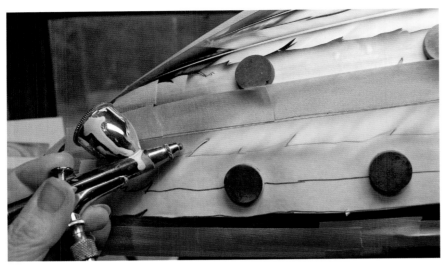

Using a pencil, I figure out where the centerline of the feather is and draw a line. Then the upper half of the feather is taped off. I remove the crown cap from the airbrush so I can get in close. Holding the airbrush at an angle to the surface, I spray in some white. Try to visualize where the light hits the feather. Use darks and lights to create a softness to the feather surface. I'm airbrushing using a diagonal up-and-down motion, creating random areas of light. See how I am creating a sheen on the feather? Then I run a little shadow along the bottom edge of the tape. This is for the shadow under the vein of the feather.

ESSENTIAL TOOLS

You may not think of tape as a tool, but good tape can help make a project run much easier. How? The quality of the adhesive on the back of the tape determines how good of a tool it is. Cheap tape means cheap adhesive and can leave behind bits of this adhesive on surfaces, creating more work for the artist. Sometimes those bits of adhesive can be rubbed off, but sometimes they can disturb the paint underneath it, requiring rework. I have used all kinds of tape over the years and had to pay the price when I used "bargain" tape. Remember time is money. I like to use good quality tape like 3M's green masking tape, which is a low-tack tape. It sticks very nicely but also pulls up without sticking too hard to the surface under it. When you are working with fragile bits of stencil and sticking tape to them as I am in this chapter, you don't want the tape to destroy the stencils underneath by pulling them up.

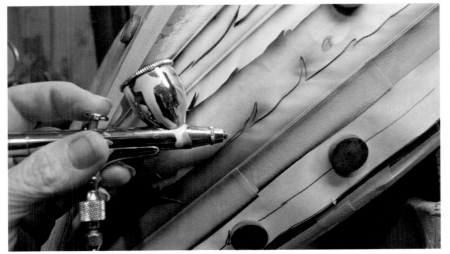

Next, I tape off and spray the top half of the feather using the same technique previously given. I use green masking tape when taping over stencil material. When removing the tape, I pull it in the direction of any trimwork on the stencil so the tape pulls off rather than away, possibly pulling a piece off the stencil. For example, the tape could easily pull off the little cuts in the feather stencil pieces and tear the stencil, so care must be taken to prevent this from happening. Note the feather on top that overlaps the feather I am working on. A shadow must be painted to create the illusion of depth.

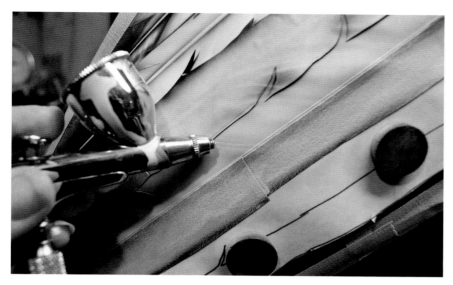

I keep the airbrushing loose and light. It's very easy to get too "line-y" and lose the illusion of softness. I do throw a few hard lines in, though, keeping it very random. Again, the airbrush motion is diagonally up-and-down, but in the opposite direction, creating soft lines of white.

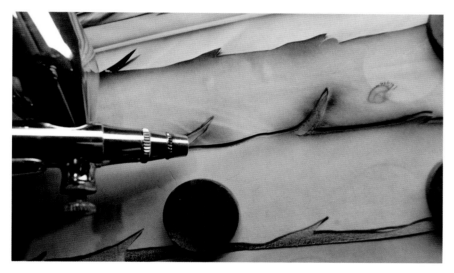

Now I use the stencil piece for the shadow under the overlapping, or top, feather. I line it up where it will fit but leave a slight gap between it and the stencil piece above it. I softly airbrush a thin mix of black paint.

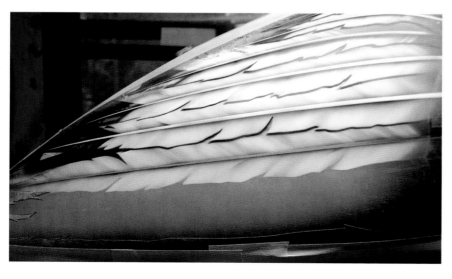

And another feather is almost finished.

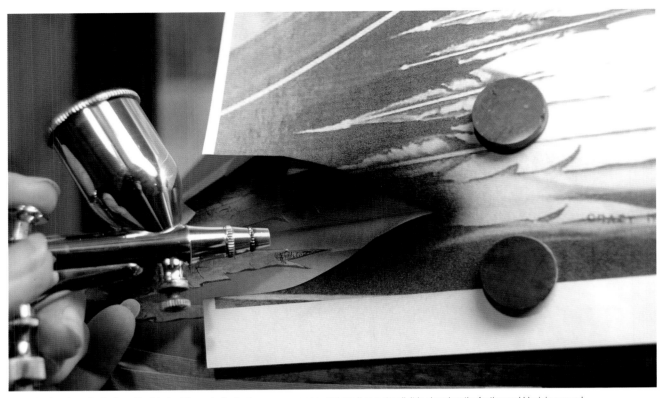

I want black ends on the feathers. For this, I cut the end off a feather on a paper copy and use it as a stencil. It is placed on the feather and black is sprayed.

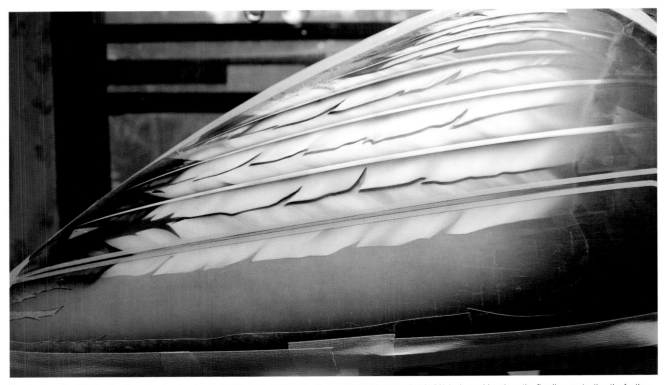

Now for the vein of the feather, I use fine line tape to mask off the line for the vein. Then I run masking tape that is 3/4-inch or wider along the fine line, protecting the feather from overspray. I airbrush white along the gap in the fine line, directing the spray toward the top half of the gap. This will create a slight shadow on the lower portion of the vein.

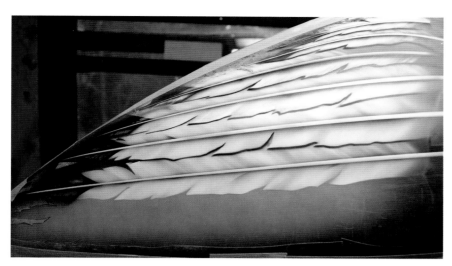

One more feather is completed and onto the next one. This method can be used for any kind of feathers, whether for a single or a grouping of feathers like those on the wing of a bird. Use layering techniques like this. For a big group of feathers, the technique can be simplified.

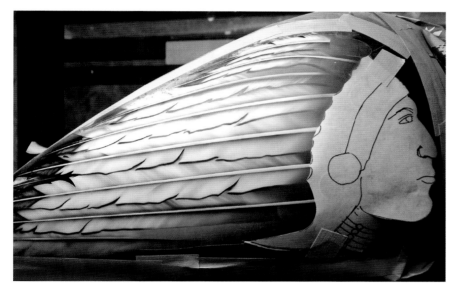

The feather portion of the headdress is complete, so I move on to the beaded front part. The front part of the stencil cutout is taped into place on the mural. The area under the beads is black, so I run some fine line tape along the edge of the stencil and mask off the feather area to protect it. Then black is sprayed.

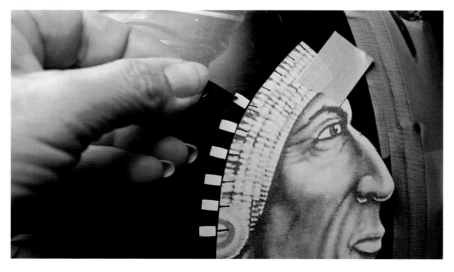

In this photo, you can see where the bead area was taped off and sprayed black. The places where the beads will be are marked on one of the paper copies, which is trimmed and placed onto the mural to help with bead placement. I have used a plotter to cut out stencils for the beads. Using the reference marks on the paper copy, I line up the bead arrangement.

HIGH TECH VERSUS LOW TECH

In this book I use some stencils cut by hand and some cut using a plotter. I want to clarify that you do not need to have a plotter to create good stencils. In cases like this where I need lots of small stencils for repetitive airbrushing, then sure, a plotter makes the work go much faster and far easier, but these same stencils can be cut out by hand. It just takes time and patience, but it is hard to get the same quality with a hand-cut stencil for objects like these.

An artist does not always have a choice. One thing a low tech artist can do if he or she does not want to cut those stencils by hand is to create a simple vector drawing of the object using a program like CorelDRAW or Adobe Illustrator. The artist can take that file to a local sign shop that will cut some stencils using a low-tack plotter film designed for stencils. Gerber Mask is what I use.

In fact, many times I use Gerber Mask for my hand-cut stencils because it is so easy to work with. For 15 years, I airbrushed complex murals without a computer or plotter. I could not work without them nowadays, but the bottom line is that I did create wonderful murals without them before. Use the tools you have and make the most of them.

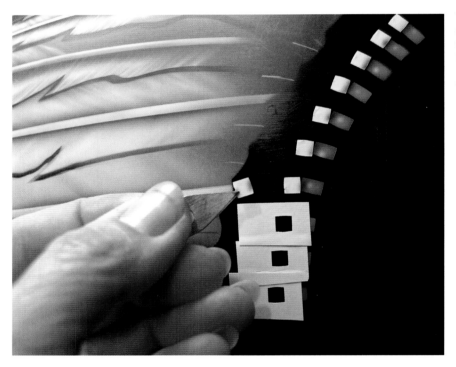

The next line of beads follows the first one. The beads are arranged using the cut-out stencil pieces. The stencil is placed around the bead, and the cut-out piece is removed using Uncle Bill's Sliver Grippers. I go down the whole line of beads until all the beads are taped off.

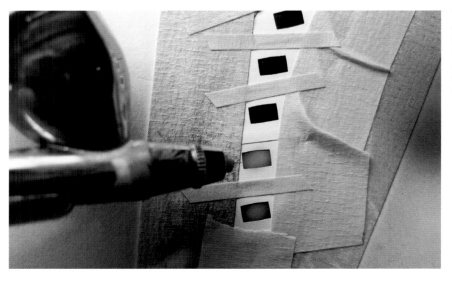

Then the bead area is masked off and each bead is sprayed. I go down the line, spraying each bead with a light color mix, in this case a light purple/red. The mix is directed at the center of the bead to create shadow and dimension. By directing the paint toward the center of the bead, the edges have a bit of shadow to them, giving the bead roundness.

I want these beads to have a faded look, so I am airbrushing a stripe on each end using a candy purple mix. On the solid-color beads, I will very lightly airbrush a thin black mix around the edge of the bead to create shadow. Last, I airbrush a white highlight in the center of each bead.

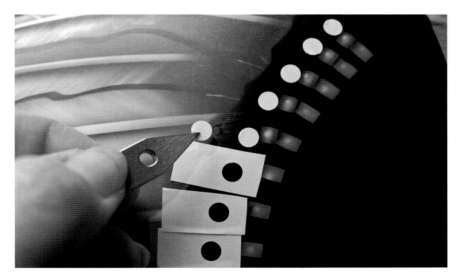

The process is repeated until all the lines of beads are airbrushed. One thing to keep in mind is the placement of the beads. If you look closely you can see where the other end of each horizontal bead line is marked in pencil. The bead lines have a slight curve to them to help create a natural feel to the headdress.

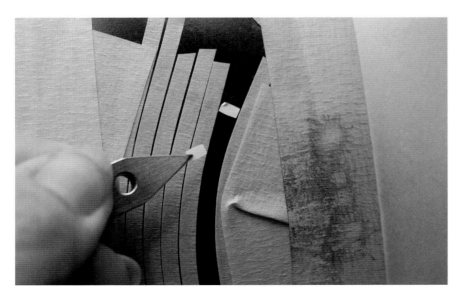

Now the larger beads are done, and I need to airbrush the little seed beads on the very front of the headdress. There are five lines of beads. I use 1/8-inch masking tape to arrange the lines. The bead cutouts help me check the spacing of the tape. Then one by one I airbrush the beads using plotter-cut stencils.

Here are the airbrushed seed beads and the stencil I am using to create them.

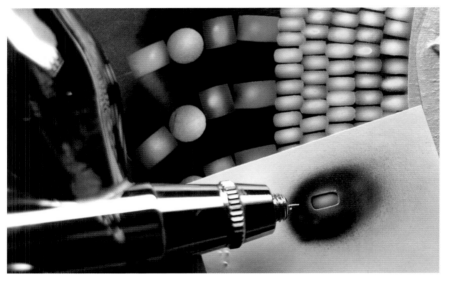

It looks like a lengthy process to do it this way, but it actually goes rather quickly. I simply place the stencil where I want a bead and airbrush white, again directed at the center of the opening. I follow this up by very lightly airbrushing black around the edges. Then I airbrush a small spot of white in the center of the bead. The stencil is pulled up and moved down for the next bead. Although the rows are uniform because each bead is individually sprayed, they are not *perfectly* lined up. This creates a nice natural feel to the mural.

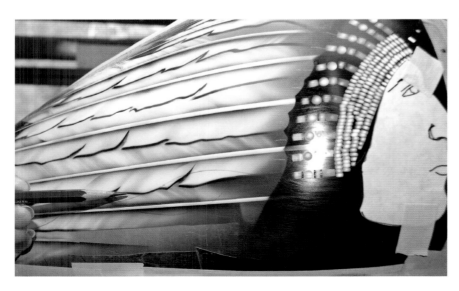

Now for some more arranging. Using a brown Stabilo pencil, I lightly sketch out where the hair will be. I do this to help with the placement of the fluffy trim feathers that will be airbrushed next.

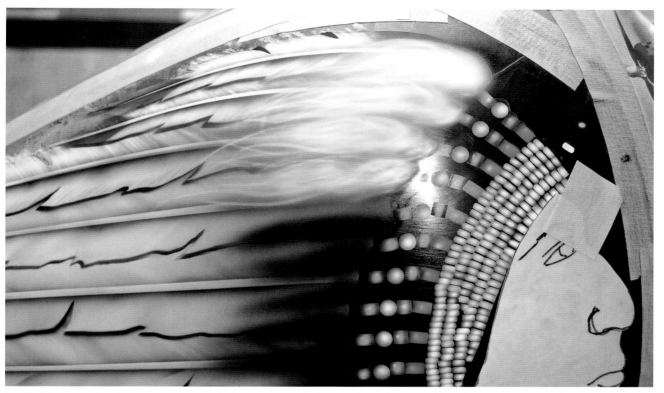

Small fluffy feathers run from the ends of the beads covering the front of the big feathers. Now that the beads are finished, I know where to start each fluffy feather group, but first there needs to be a shadow under these feathers. Black is airbrushed where the feathers will be. Next I start airbrushing the feathers freehand using white.

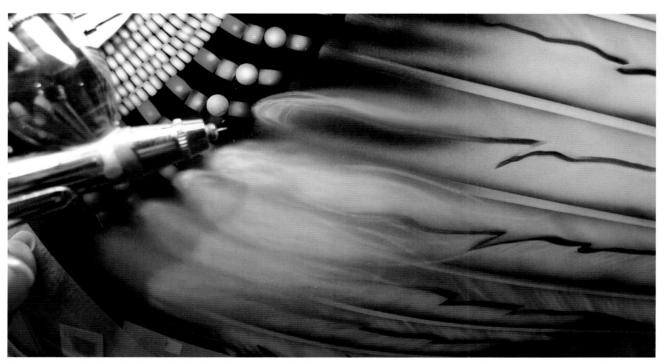

This photo is not upside-down, but the tank is. Since I am left handed, I tend to airbrush better when I am spraying to the right. I flip the tank over so that I can airbrush to the right. I start each fluffy feather at the end of a bead and run a line of paint. Just like when spraying the other feathers, it is very easy to get too "line-y" here. So again, I keep it very random, airbrushing large sections of white in various places on the feathers. OK, now we continue onto Chapter 10, Hail to the Chief, Part 2.

KNOW YOUR STRENGTHS

I airbrush better back and forth (horizontally) than I do up and down (vertically), so I use this to my advantage. I also airbrush better during the day than I do at night. My skills are fresher and sharper in the morning, and I find that after eight hours my skills tend to fade. I get tired and start making mistakes. So know your strengths and your weaknesses and use them to your advantage. Keep track of when you make stupid mistakes. Are you making most of them at night or in the early morning? While you are paying attention to your airbrushing, also pay attention to the artist—yourself. While you are fine tuning your skills, fine tune how you work and get the most from your art and yourself.

A SIMPLE THING

What do these murals have in common? They were both painted using a window screen. Simply put down the color you want the mesh area to be—that is, the color that the lines of the screen grid will cover. Here, the lines covered a gray color. I taped off the blue areas, placed the screen over it, and airbrushed in blue. Then I repeated this step.

Here, I paint the buildings in brown tones. Next, I tape off the building to reveal only the window area. Placing the screen over it, I spray a yellow/white mixture while moving the airbrush in a diagonal motion.

154

Chapter 10
Hail to the Chief, Part 2

PAINTING SKIN TONE

In four of my previous books, there have been chapters on painting skin tone. This chapter focuses on painting the tones of a face. Rather than spending time going over the way the colors work together, I will focus on techniques used to paint those colors. I'll very quickly go over the basics of skin tone paint mixture here.

For skin tone, I start with white and add a little of a root beer-colored toner. Most paint companies have their own version of this. For fine art paints, it is usually called Burnt Sienna. For automotive colors, it usually has it own name and number. House of Kolor calls

its version Root Beer Kandy Koncentrate (No. KK07). PPG's number for its version is DMD623.

Into this mix, I add a little yellow and red. Then I will make up lighter versions by adding white and darker versions by adding a brown/black mix.

Remember, all skin tones are different. Some have more yellow, some more red. Also, lighting can play a role in the color tone of skin. Study photos of people and closely examine the differences in the skin tone. Experiment and play around with your skin tones. Like everything in art, there are no hard and fast rules.

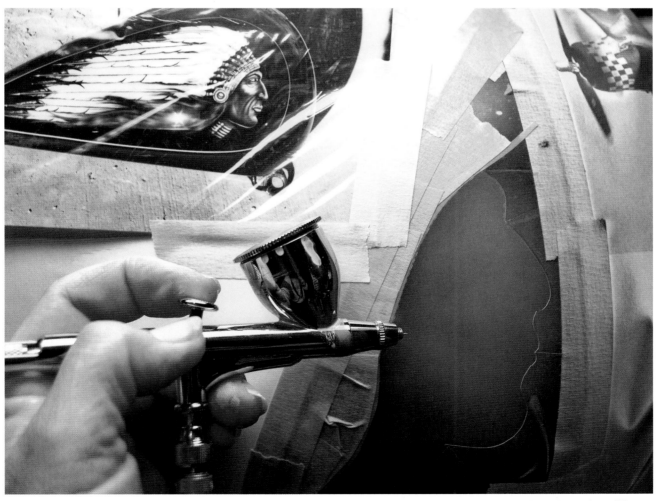

The headdress is masked off, and the work on the face begins. The reference photo is covered with a plastic bag to protect it and taped very close to the mural area. This makes it easier to reference and compare. Then the skin tone mixture is lightly airbrushed over the face.

I made copies of the original that I am painting. These copies are the same size as the mural; some will be used for stencils, and one will be used for transferring the facial features to the surface of the mural. I have trimmed this one so that the face is cut out and then flipped it over. I run a pencil over the reverse side. This creates a sort of carbon copy.

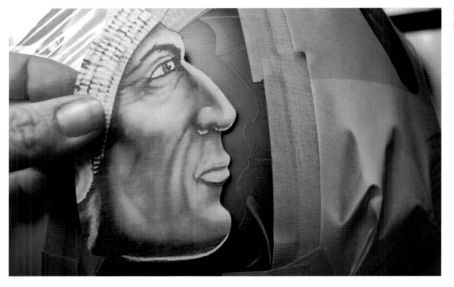

Now the copy of the face that is covered with pencil is put into place on the actual mural.

Then, with a pen I trace along the feature lines, like the eyes, eyebrows, nostrils, lips, and dimples.

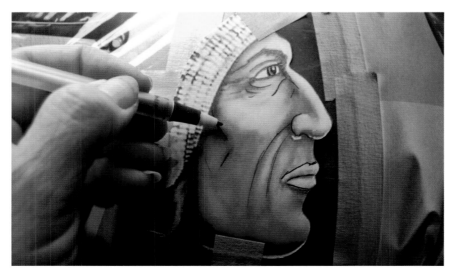

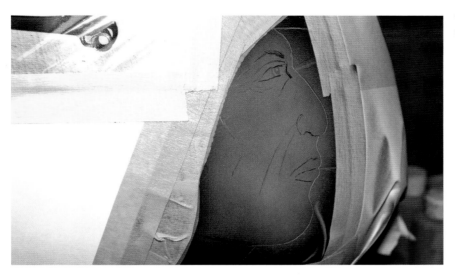

The paper transfers these features onto the face and will make it easier to airbrush.

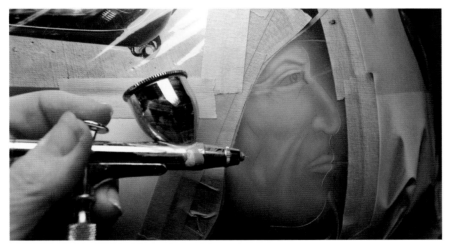

I start out using skin tone and carefully airbrush in the lighter shades on the face like the skin folds between the dimple wrinkles, the eyelid, the lips, and the nostril.

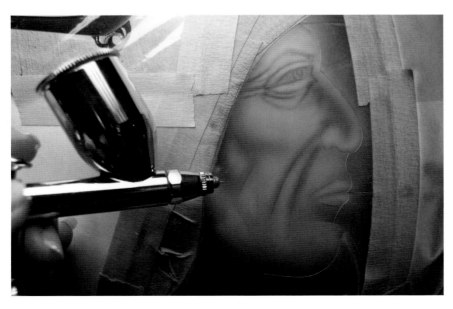

Next, I use the transparent brown color and airbrush in the shadowed or darker areas of the face. Note that I have removed the crown cap from the airbrush. This way I can get right in close. The transition between dark and light should be smooth and gradual.

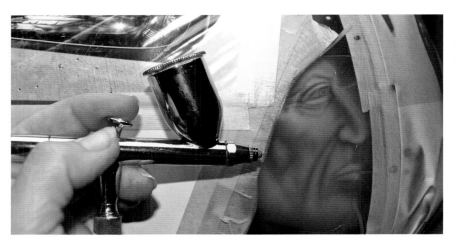

Then, the transition is made even more gradual, and the shading is expanded more into the lighter areas. At this point, I even apply a very light layer of transparent brown over the entire face.

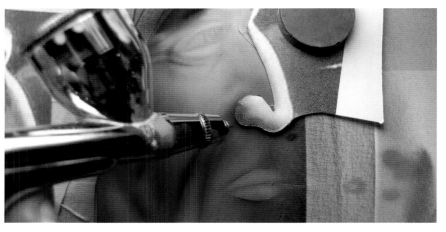

I create some stencils from the paper copies of the original face. Each copy has a feature cut out. For example, one copy has a nose cut out, another the eye, another the eyeball, another one the lips, and so on. I take the nose stencil and very *lightly* airbrush the brown/black mixture around the nostril, taking care to direct the spray toward the bottom of the nose so a hard line is not created in an area where it's not necessary.

PAINT IS ONLY PAINT

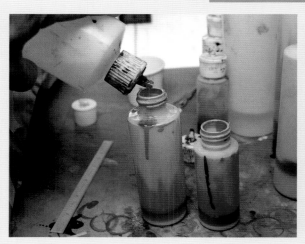

I keep my mixed color tones in plastic bottles from www.coastairbrush.com. These bottles seal up pretty tightly, but some reducer does evaporate out. Always check your mixtures before you pour them into the airbrush. Chances are you will need to add some reducer.

Paint settles! See the layers of different colors in the previous photo? The heavier colors will settle to the bottom of the bottle. White is a heavy color and seems to always settle at the very bottom. Be sure to agitate your paint by shaking or stirring until it's *completely* mixed!

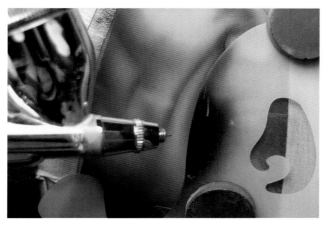

Here, I airbrush dark brown against a large curve on the FH-6 Artool Shield to add depth and sharpness to a dimple wrinkle on the face. I have already done that process on the wrinkle above it.

How do you paint a face? Quite simply, everything you need to know is right there in front of you in the reference picture—all the answers. All you need to do is look, and look and look, and then look some more. Examine the face very carefully, the shading, the coloring. Look at the nose, how the color changes, lightens and darkens around the nostrils. The lips, how full are they?

Not sure of something? Then measure! Use a good quality 6-inch steel ruler. If your face is looking awkward, then get out your ruler, measure the various features on the face in the reference picture, and compare those measurements to the face in the mural. Do the eyes look weird? Are they too far apart, too big, or too small? Are the lips too far from the bottom of the chin? Measure!

Here I am preparing to shade the lips using the FH-6 shield by finding a curve that matches. Look closely at the nose and see how the previous steps using the copy stencils have affected the shading of it. Here a curve is matched up to the curve of the lips and dark brown is very lightly sprayed.

Now I prepare to shade and define the chin area. I don't want to overdo it, so instead of using a dark brown, I'll use a thinned-down mixture of the transparent brown. I hold the shield in place just above the chin area and make one light pass with the brown. In this photo, you can see the line of the chin just above the shield.

HAIL TO THE CHIEF, PART 2

ESSENTIAL TOOLS

I have said it before, but it bears repeating: Artool Freehand Shields FH-6 and FH-5 are *essential* for me when it comes to painting faces. Between the two of them, I can find a curve for nearly every curve on a face, including eyebrows, noses, and lips. Simply hold up FH-5, the Mini-Shield, to a picture of the face you are painting and find all the shapes and curves on the face that fit the various shapes on the shield. You can shade, shadow, and highlight eyes, eyebrows, eyelids, lips, noses—almost anything.

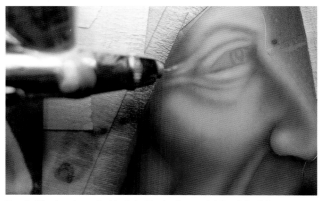

Now that the face is roughed in, I start to give it more detail and depth by airbrushing some lighter skin tone on the lighter areas like the middle of the folds of the wrinkles.

LESS IS MORE

Go light when you are shading. It is very easy to overdo it and go too dark or too light. This can create a fake look and make a face appear made up rather than realistic. Apply thinned-down mixtures at low air pressure, maybe 15 pounds or less, and then just airbrush one or two strokes over the area. Then go to work on another area of the face. This will not be easy because it is very tempting to continue to add more color. *Don't!* If you look at a person's face, you do not see drastic changes in the color tones across the surface of their face, rather there are soft transitions of tone. You can always go back and add more tone or color, but try to use less at first. Work your way across the face softly, and you will create a soft, realistic skin surface.

I move down on the face, aiming the airbrush right at the points that I want to appear the highest on the facial surface like the high point of the cheekbone, similar to the center of the wrinkle folds.

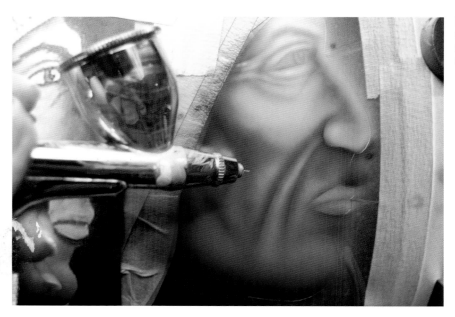

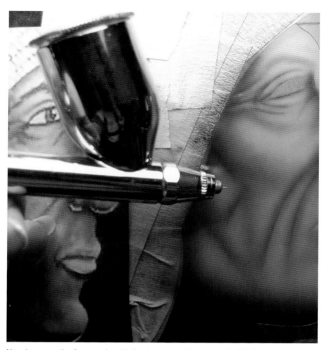

Now I go over the face again with the transparent brown, only this time I apply even less of it. I am now working with very small amounts of paint, that is, making one or two passes with paint that has been thinned way down by maybe 150 to 200 percent. Little by little, the color layers of the skin build up, creating form and depth.

Now to airbrush some final details. Thinned-down brown/black mixture is very lightly airbrushed along the fold above the eye using the Artool FH-6 shield.

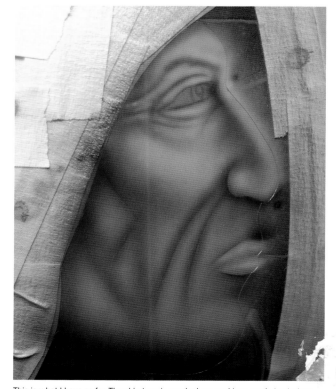

This step is repeated with the top of the eyelid and anyplace else that needs to be defined or sharpened up.

This is what I have so far. The skin tone is nearly done, and I am ready to start on the details, such as the eyes, eyebrows, and any other feature that does not use skin tone.

Now for the eyebrows. Using a paper copy stencil, I place the top piece at the top border of the eyebrow and airbrush thinned-down black. This is repeated on the bottom border of the eyebrow using the bottom half of the stencil, which is seen in this photo.

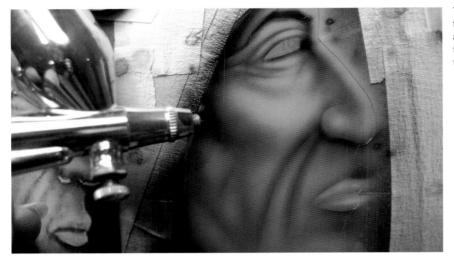

Then a little bit of black is airbrushed over the brow to soften it up slightly. Next, the thinned black is airbrushed into the shadowed areas like the hollows of the cheeks, the sides of the nostril, and very softly at the deepest places of the wrinkle folds.

KEEP IT CLEAN!

Another really great thing about these Artool shields is how you can use them to help judge how much color has been airbrushed *if* they are kept clean. In this photo, you can see how much black has been airbrushed by looking at how much has landed on the shield. To clean the shields, use whatever kind of reducer you use for your paint. Since I use automotive paint, I use enamel reducer to clean the shields, but I try not to soak the shields with it. Pay attention and use care when cleaning your shields. If it seems like your shields are turning soft or being affected by the reducer, then find some other way to clean them.

A SIMPLE THING

While you are looking at the photos in this book, don't just look at the center of them, look at everything in the picture. Examine how I set up and position parts to paint and how I always test fire the airbrush away from the surface of the mural *before* applying paint on the mural. Here, I am getting ready to airbrush a highlight on the lip. Just to the right of the lip, you can see where I am testing out the airbrush to make sure it is spraying correctly and that my paint mixture is correct.

For example, sometimes the airbrush needle is stuck or not seated properly in the tip. If this is the case, when you go to airbrush a small detail, a large amount of paint might shoot out and splash over the area. By testing the airbrush first, that is one problem that will be caught before it happens.

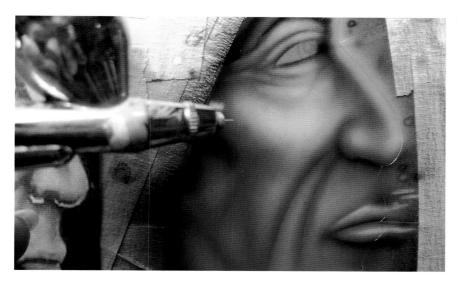

The highlights have been painted on the lips, the nose, and the cheek.

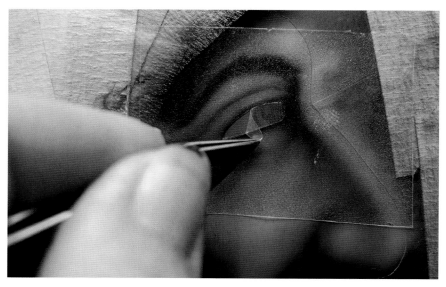

Now for the eye, I can airbrush it several ways. I can cut a stencil for the eyes using the paper copies. In fact, if the face is small enough, like on a pinup girl, that is what I would do. But this face is bigger, and bigger means easier to work on. Since this face is 2 inches wide, I have more freedom to try different methods. To mask off the eyes, I apply a piece of clear transfer tape. Using a No. 11 X-Acto stencil knife, I cut out the eye area and remove it with a pair of tweezers. Then I tape off the area.

BIGGER IS BETTER

. . . well, when it comes to airbrushing anyway. Airbrushing a face the size of a thumbnail is far more difficult than airbrushing a face the size of a cell phone. Working smaller means reworking details over and over until they are sharp. Trying to cut a stencil that is less than 1/4 inch is very hard, and airbrushing an eye of the same size is extremely tedious. A larger face that is 2 inches wide might take me an hour or two to airbrush properly, while a face that is 3/4-inch wide might take me four hours. Then I would most likely go back and rework it for another two hours after applying clear coat to give me a fresh surface to work over.

Using a curve on the Artool FH-6 shield, white is sprayed. I hold the shield so that only the white part of the eye is revealed. The curve on the shield creates the curve of the eye's iris.

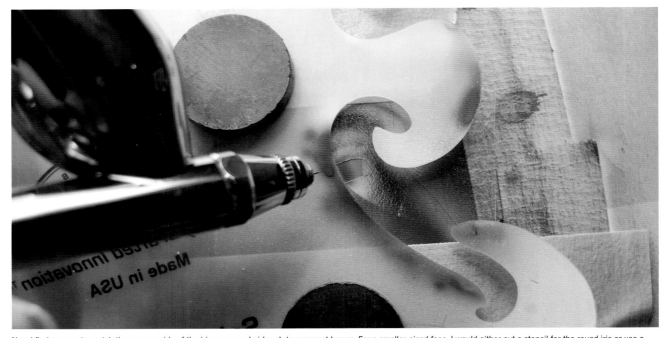

Now I find a curve to match the reverse side of the iris curve and airbrush transparent brown. For a smaller-sized face, I would either cut a stencil for the round iris or use a circle template or my plotter to cut some circles in the correct size.

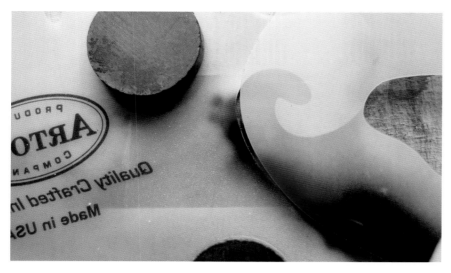

Now to paint the black or dark border around the outer edge of the iris. The FH-6 shield is held in place with magnets, while another shield is held up, creating a slight space between the two shields. Then black is sprayed.

Another curve on the FH-6 shield is used to airbrush the pupil. A cut stencil or circle template or any cut-out circle can be used too. The shield is held up along the left side of the pupil and black is sprayed.

Here, I have pulled the stencil back just a bit to show what the pupil looks like now.

Now for the white highlight on the eye. This little trick is very handy for creating any kind of small circle. I place a piece of clear transfer tape over a hole on a shield. Using an old airbrush needle, I pierce a hole in the surface. Depending on the size of the needle and how far it is pushed through the material, just about any size of tiny circle can be created.

Then the shield is held in place over the eye and white is sprayed. The great thing about this method is that because the material is transparent, it is very easy to place it *exactly* where the circle needs to be. You also can quickly create as many circles as needed.

I want to airbrush a thin black border along the upper line of the eye. Leaving the transfer tape around the eye in place, I match up a curve on the FH-6 shield. This curve is held right up next to the edge of the transfer tape, leaving a very thin gap between the tape and the shield. Finally, black is sprayed.

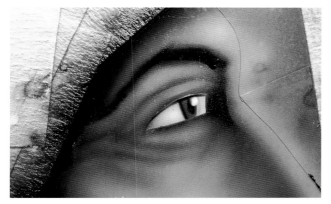

I always save the eye for last because the eye has very fine details and different colors than skin tone. If I painted the eye earlier in the process, overspray from working on the skin would get on the eye, clouding it. Chances are I will still find things I want to rework on the skin, and if so, I'll cover the eye with a shield or clear transfer tape.

Whenever you are painting any part of a mural, no matter what, plan the order of how you will airbrush the various items in each part of the mural.

Now you can see the various details I just airbrushed and how all these methods worked together to create an eye.

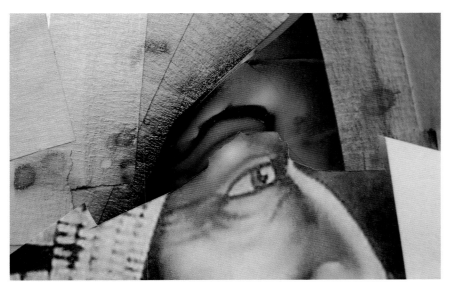

The upper brow needs more light skin tone applied to it. I trim a paper copy of the face, hold it up in place, and then airbrush the skin tone. Here you can see the stencil piece just under the eye area after the light skin tone was applied.

The neck is masked off, and dark skin tone is airbrushed.

Then it is shadowed with darker brown/black.

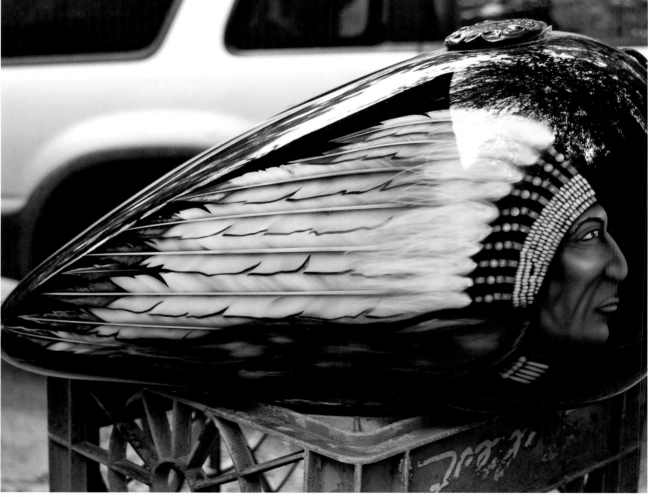
The finished chief.

Chapter 11
Fixing a Face

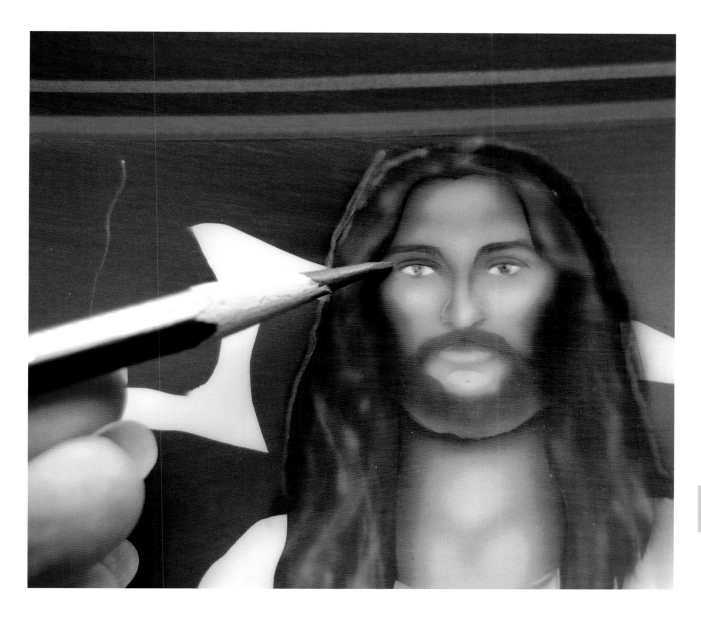

Here is a portrait I am working on. I need to change the way it looks. The eyes are too indistinct; the face does not have enough definition. There are just a number of reasons that add up to make the face not have the appearance I want it to have. The area to the right of the nose needs to be lightened, and the area to the left needs to be touched up. The beard, mustache, and hair need to be lightened. The hair also needs to appear straighter.

I am working over a clear-coated surface. Any changes I make can be removed without disturbing the paint underneath, plus the surface is very smooth and easy to work on. If the surface was not smooth and flat, it would be very difficult to do this next step. With a brown Stabilo pencil, I draw lines to better define the eyes. These pencils can be used for drawing directly on painted surfaces, and they are pretty solvent-proof if the first few layers of clear are applied lightly.

FACE PAINTING FOR IMPERFECT ARTISTS

I am not a perfect artist. Things I paint do not always come out looking the way I want them to the first time around. Faces are one of those things with which I find I need to have several tries. What I do is paint the face as good as I can the *first* time I am working on it. Then I apply clear coat to the mural and wet-sand it with 600-grit paper. This gives me a nice, smooth, fresh surface to work on. Plus, if I am not happy with my rework, I can easily remove it by sanding. Sometimes I will rework a face three or four times over fresh clear coat to get it just right.

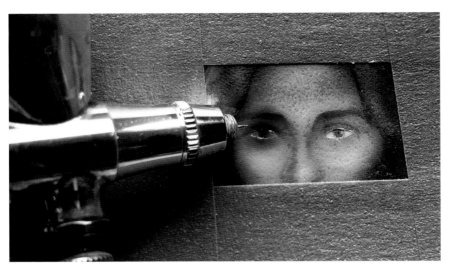

Next, the eyes: a piece of clear transfer tape is laid over the eyes. Then using the eyes underneath as a guide, I very carefully cut out the round pupils with a stencil knife and tape off the surrounding area. First, one airbrush pass is made with very thinned-down light flesh tone. Next, a pass with thinned brown/black mix is made. Then I make holes that are the same size as the pupil in a piece of clear transfer tape using an airbrush needle. I line up the pupil-sized hole over where the pupils will be and make one pass with the black. This step is repeated for the white highlight in the eyes.

Here are the paper copy stencils I made when I started working on this face. I will be using these to fix it.

With a paper copy stencil is place, light skin tone is very lightly airbrushed on the right side of the nose. Then the stencil is repositioned and darker skin tone is sprayed on the left side, next to the nostril.

Now the beard is masked off with the paper stencils. When spraying the light skin tone on the beard, I move the airbrush in an up-and-down motion the direction of the beard. Then I spray a thin wash of brown/black mix that is just enough to darken the lighter color without covering it.

Now I carefully mask off the face using transfer tape trimmed to fit for the sides of the head and masking tape for the center of the face. Then, the straight hair is airbrushed in with the light skin tone. This is followed by a wash of transparent brown and brown/black mix.

LOW PRESSURE!

When working with detail like this, low airbrush pressure is key. I am using very thinned-down paint, as well as very finely cut, tiny stencil pieces. The pressures I am using in this chapter are 15 pounds or less. A higher pressure would blow the stencils around, so they would not stay down firmly against the surface. Keep the pressure from the airbrush directed at the stencil, not at an angle that will blow the stencil off the surface.

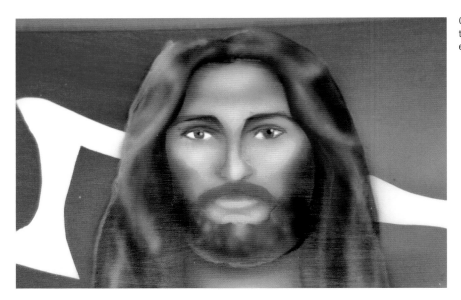

OK, the face looks better, but there is still a problem: the eyes look a little funny. It's the highlight in the right eye. It's too high; it needs to be more centered.

The highlight needs to be painted over—and only the highlight, nothing else. Using a piece of transfer tape, I make holes that are the exact same size as the highlight. The hole is lined up directly over the highlight, and one airbrush pass is made with the brown/black. This covers the old highlight so the new one can be painted in the correct place on the eye using the same piece of transfer tape.

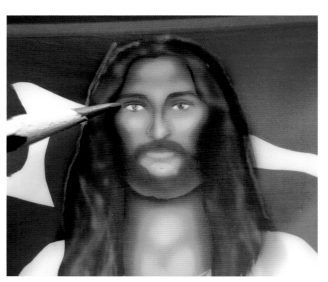

Compare this new face (right) to the one we started with (left). Note the side of the new face. It is nearly as small as my thumb. Imagine painting a face as small as your finger.

THE FACE QUESTION

OK, why is this face such an effective piece of artwork?

1. It is simple. The eyes are closed so that they are just thin lines. This way more focus can be concentrated on the eyelid and eyebrow. Another example of less is more.

2. Look closely at the way the light hits the face. Usually faces are shown with light hitting them from the front. Here, the front of the face is shadowed, making the face look different, and therefore it gets attention. Plus, since the light source illuminates the side of the face, there are only a few major shadows on it, like the cheekbone, jaw, and around the eye. This means fewer lines, fewer areas of detail on the face, and more simplicity.

3. I had a great photo to work from.

When airbrushing a face, you can redesign it to look any way you want it. You can add and take away things, change the shape of the nose or the jaw, or clean up the lines.

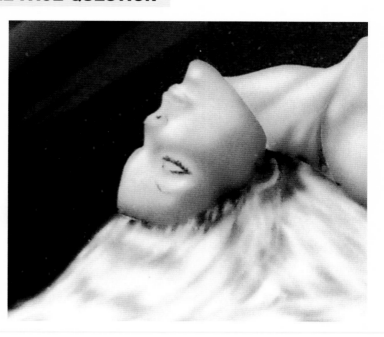

A SIMPLE THING

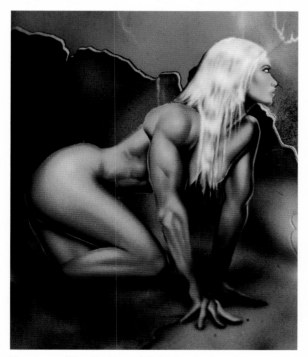

The customer did not like this mural. He felt the woman looked too manly. She needed to be muscular but also retain a more feminine look. I liked what I had and wanted to work with it.

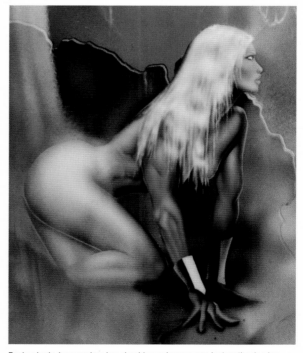

For her body, I covered up her shoulder and upper arm by lengthening her hair, and painted bracelets on her arms. For her face, I simply lightened up the eyebrow. Otherwise, I made no other changes, but look at what a difference they made!

Index

The Best Tools for the Job.

Sheet Metal Fabrication

101 Harley-Davidson Evolution Performance Projects *2nd Edition*

How To Rebuild Corvette Rolling Chassis 1963–1982

How to Paint Your Car

Other Great Books in This Series